DESTINATION WEDDINGS

The Photographer's Guide to Shooting in Exotic and Unexpected Locations

JAVON AND DAWN LONGIELIERE

Amherst Media, Inc. Buffalo, NY

DEDICATION

To Cade. You're the best experience in our life that didn't require a passport and an airline ticket. We love you to Paris and back!

Love, Mommy and Daddy

Published by:
Amherst Media, Inc.
PO BOX 538
Buffalo, NY 14213
www.AmherstMedia.com

Publisher: Craig Alesse
Senior Editor/Production Manager: Michelle Perkins
Editors: Barbara A. Lynch-Johnt, Beth Alesse
Acquisitions Editor: Harvey Goldstein
Associate Publisher: Kate Neaverth
Editorial Assistance from: Carey A. Miller, Roy Bakos, Jen Sexton, Rebecca Rudell
Business Manager: Adam Richards

ISBN-13: 978-1-68203-176-6
Library of Congress Control Number: 2016945471
Printed in the United States of America
10 9 8 7 6 5 4 3 2 1

AUTHOR A BOOK WITH AMHERST MEDIA!

Are you an accomplished photographer with devoted fans? Consider authoring a book with us and share your quality images and wisdom with your fans. It's a great way to build your business and brand through a high-quality, full-color printed book sold worldwide. Our experienced team makes it easy and rewarding for each book sold—no cost to you. E-mail **submissions@amherstmedia.com** today!

www.facebook.com/AmherstMediaInc
www.youtube.com/AmherstMedia
www.twitter.com/AmherstMedia

CONTENTS

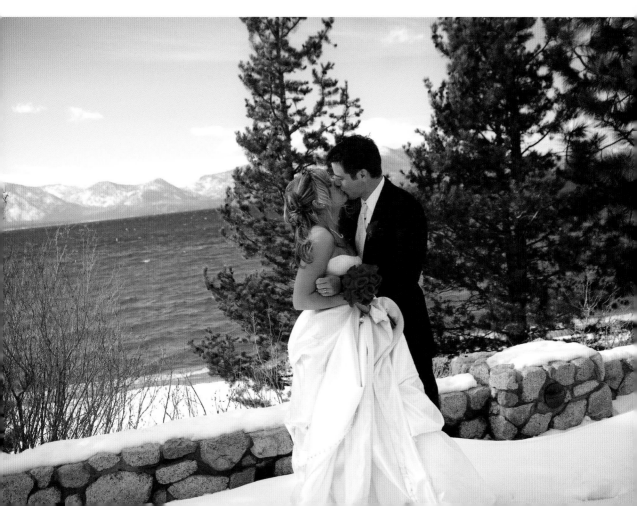

ABOUT THE AUTHORS

Javon and Dawn Longieliere are international wedding and lifestyle photographers with offices in Atlanta and Valdosta, Georgia. The couple started Javon Longieliere Photography in 2001. For the past 15 years, they have been traveling all over the world shooting weddings and portraits. Destinations have included France, Costa Rica, the Dominican Republic, Spain, and the Bahamas. Inside the U.S., they have been to Alabama, California, Florida, Georgia, Maine, Nevada, New Jersey, New York, Tennessee, and Texas. They are now one of the most recognized and sought after photography teams in the country.

The body of work that Javon and Dawn have produced has caught the attention of publishers both nationwide and in local areas. Their images have appeared in *Grace Ormonde Wedding Style, The Knot, Get Married, the Atlantan Brides, La Bella Bride, Atlanta Weddings, Central Florida Bride* and *I Do.* As well as capturing the attention of commercial markets, they have also commanded the attention of their fellow photographers. Their images have been published in the Wedding and Portrait Photographers International Albums (2004 and 2005), which feature the best work that year. They were also featured in the professional monthly periodical for WPPI as a "Member of the Month" in September of 2006. They were interviewed by the New York Institute of Photography in 2005. In April 2006, they were interviewed by The WB television network for a special on weddings. Their work has also garnered over twenty international awards given by three of the most prestigious organizations in the industry: PPA, WPPI, and WPJA. In 2009, they were ranked #16 in the world by the Wedding Photojournalists Association and #1 in Georgia. In 2011, they began offering photography workshops for both professionals and amateurs.

Javon has earned the Certified Professional Photographer (CPP) designation from Professional Photographers of America (PPA) as well as the Photographic Craftsman (Cr.) degree.

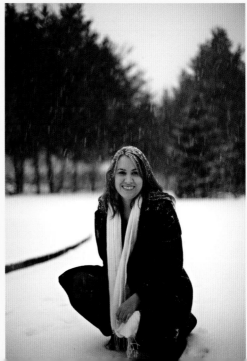

INTRODUCTION

When I started our studio, I never thought that I would be on the road as much as I have been. I wanted to be a small town portrait photographer, and I didn't have any desire to photograph a wedding. By my third wedding, I was hooked—and after three years in business, we got our first "big city" wedding, in Paris! I had never expected that. I can trace back to those first few years almost all of the weddings we have ever photographed. None of our weddings, though, are more connected than our destination weddings. We can trace almost every one of the overseas weddings we have ever photographed, in some form or another, back to that first wedding in Paris.

Getting started with destination weddings is not as difficult as it might seem. In this book, you will find out how we interact with the different players in the wedding itself, from the planners, to the venues, and the clients themselves. You will also learn how we created some of our most iconic wedding images, often with very little equipment. After all, we don't travel with much gear. Along the way, you will find out our philosophy about the images and the weddings themselves and will learn why we do things the way we do them. Don't get me wrong; there are some drawbacks to photographing destination weddings. These include the time away from home, the payments on a house that you are never in,

the payments on a car that you drive to the airport and back, and figuring out where to put all those stamps in that tiny passport.

I have filled this book with images from some of the most incredible weddings we have ever photographed. These pages contain lots of priceless memories made over the past four years.

Grab your passport and enjoy the trip. We hope to bump into you on a flight somewhere!

"Grab your passport and enjoy the trip.
We hope to bump into you
on a flight somewhere!"

1 GETTING STARTED

MARKETING (*top*)

It's the vendors more than the prospective clients that matter most when you are trying to book destination weddings. These clients are contacting vendors in other countries, and they don't know anything about the vendors in that area. Who do you think they will ask? They will ask the venue owners and operators who they would recommend. As the photographer, you want to be on that vendor's referral list. The best way to get on that list is to have photographed there first, but what do you do if you have never been there? Introduce yourself to the venues! We interact with them on social media and we also send out books with our work in them so they get a feel for our style. Many times, we also let them know when we are hoping/planning to be in the area so that if they have any clients who need a photographer for that time period, they can make the referral.

SOCIAL MEDIA (*bottom*)

Social media is where you, as the photographer, need to live right now. Your clients and your vendors are spending their time on social media, so that means you have to as well. Don't make excuses that you don't understand how to use different platforms of social media, because if

you don't learn, you will start to lose business. Get your accounts started and get active. Comment on others' accounts and like their posts; that will get you in front of the vendors that you want to be in communication with.

CAMERA BAG *(top)*

People always ask me what I take to destination weddings and how I pack. This is my bag. It's a Lowepro Pro Runner. All of my necessities (e.g., the camera, memory cards, lenses, batteries, and flashes) go into this bag. This is everything I need to photograph a wedding. Anything else, like reflectors and tripods, gets packed into our checked luggage. If the airline loses one of our checked bags, it's not a big deal. We have everything we need.

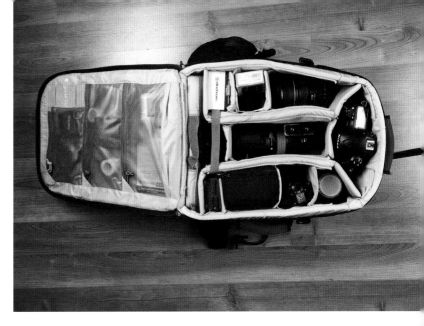

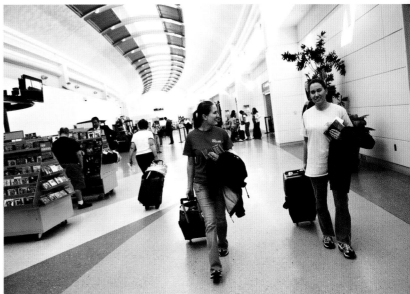

AT THE AIRPORT *(bottom)*

It *is* possible to have a good airport experience! You will need to arrive at least three hours before the flight. If it was up to Dawn, we would be there about five hours before our departure. Curbside check-in has been a godsend for us. It will cut down the time that you have to wait in line. I try to wear shoes that are easy to take off and put on so if I end up in a security line that requires shoe checks, I can get through it faster. Be prepared to have your camera bag opened and inspected. At the beginning of our career, they used to do chemical swab tests on our gear, too. Last but not least, carry your equipment on the plane with you. I'd rather have to wear the same clothes for a few days than not be able to photograph. It's happened, too!

2 ENGAGEMENT SESSIONS

AVAILABLE LIGHT ONLY *(below)*

We photographed part of Tracy and Garrett's engagement session at night in West Palm Beach, FL. I wouldn't suggest doing an entire session like this, but a part of a session can be a lot of fun! I dialed my ISO up to 2500 and used a 50mm f/1.4 lens to allow as much light as possible to enter the camera. My goal, in this case, was to use only available light without the addition of any flash units, so I could really portray the feel of West Palm Beach at night.

Exposure: f/1.4, $^1/_{160}$ second, ISO 2500. *Lens:* 50mm.

TIMING THE SESSIONS *(following page)*

Purvi and Raghav were getting married in North Carolina, but they were living in New York City and wanted to have their engagement session photographed there. When I do an engagement session, I explain that we might want to be there for a couple of days just in case the weather is bad or something comes up on the day that we were scheduled to photograph. This provides a safety net. Raghav had just started a new job, so he wasn't able to get off from work to do a complete session in one sitting, so we decided to break it up and we would photograph the first part in the morning and the second in the evening. This image was from the evening shoot on the roof of their apartment building.

Exposure: f/2.8, $^1/_{60}$ second, ISO 400. *Lens:* 70–200mm at 70mm.

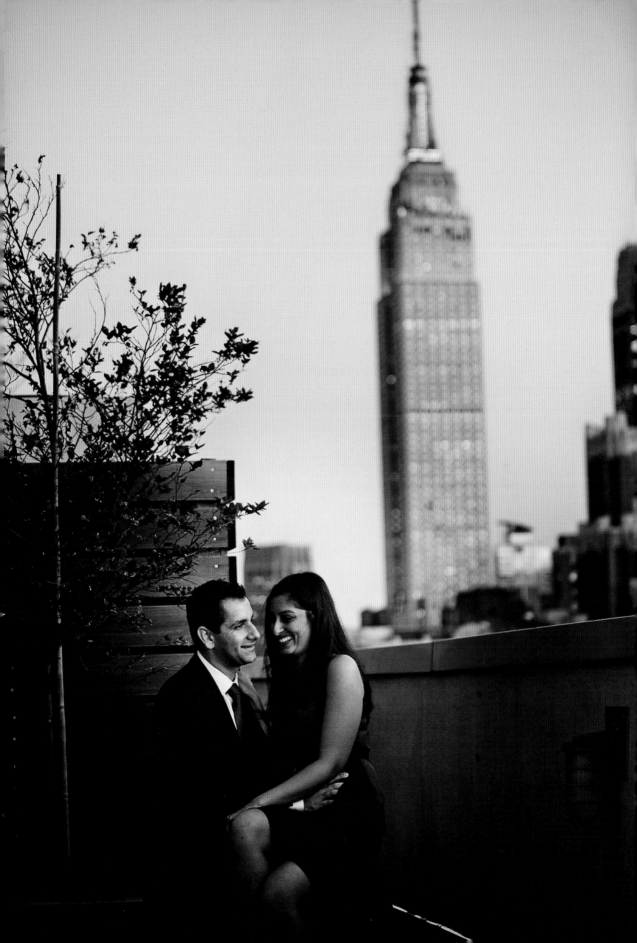

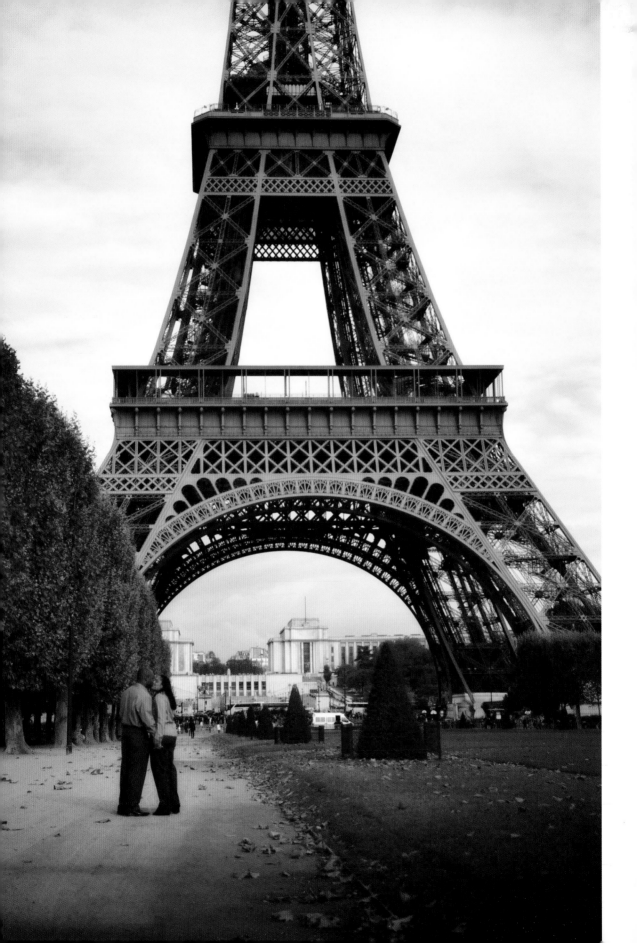

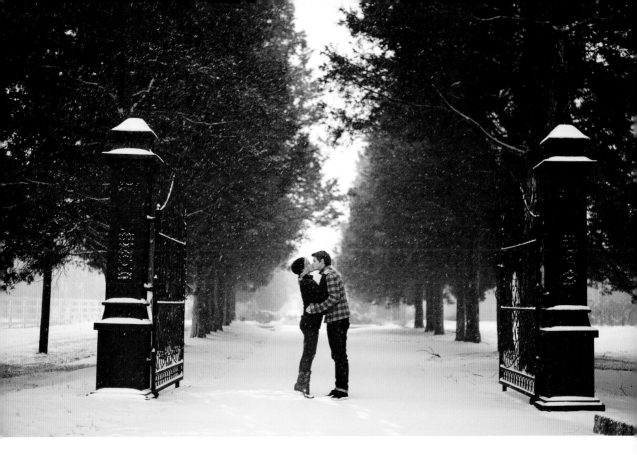

PURE ROMANCE *(previous page)*

What better place to have your engagement portraits taken but Paris, France? We were already in Paris to photograph the couple's wedding, so we carved out a couple of extra days before the event so we could do their engagement session in the city. Unbeknownst to us, anti-terrorism drills were being conducted on the Eiffel Tower on this particular morning, so we couldn't get as close as we would have liked. Sometimes, you just have to roll with the punches.

Exposure: f/2.8, $^1/_{1000}$ second, ISO 500. *Lens:* 17–35mm at 35mm.

LET IT SNOW *(above)*

We went to New Jersey to photograph Tabby and Nate's engagement session. It was a cold day, and we knew there was a chance of a snow storm that might interfere with the session. We were working quickly, but it wasn't quick enough. About halfway through the session, the snow started to fall, and by the time we were finished, it was a full-on blizzard. It made for a beautiful session and some gorgeous photographs.

Exposure: f/1.4, $^1/_{80}$ second, ISO 500. *Lens:* 50mm.

"About halfway through the session, the snow started to fall,
and by the time we were finished, it was a full-on blizzard."

3 THE PREPARATIONS

GETTING TO KNOW YOU *(below)*

Most of our clients will book us for the entire day, so that often means getting images of the getting-ready process. It seems like this would make for a long day, but it does give one time to get to know the wedding party and have time with the bride and groom before the ceremony. This is such a huge factor for me, because I love being able to call people by their names, and this time during the prep process gives me the chance to learn everyone's name.

In this case, Ashley and Josh had planned an entire weekend in South Beach doing things they loved to do, and they wanted their activities to be photographed. This is Ashley at a gym practicing kick-boxing! There was minimal light, and I didn't want to flash the heck out of her, so I set my ISO at 4000 and kept the aperture wide open to allow as much light in as possible.

Destination: Miami, FL. *Exposure:* f/2.8, $^{1}/_{60}$ second, ISO 4000. *Lens:* 17–35mm at 34mm.

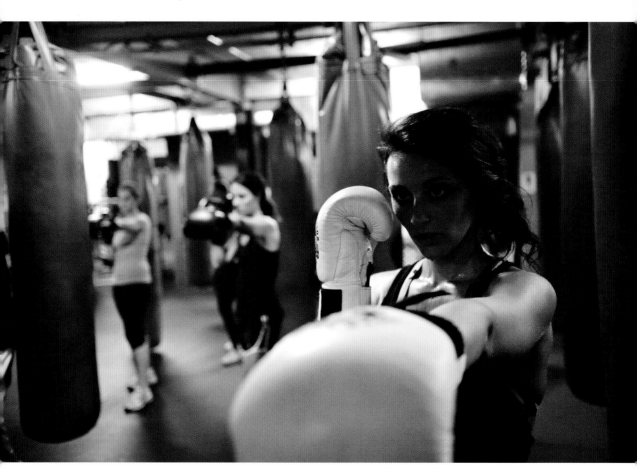

INFLUENCING THE MOMENT
(top)

These shots of Nina getting into her bridal gown were so filled with emotion and joy! Making sure that you are in the best place for lighting is tantamount to getting the best images. I used to be completely against influencing the moment, but now I explain to people that certain places are best for light, and I will position people in those lighting situations because it makes the images much better.

Exposure: f/1.4, $^1/_{50}$ second, ISO 400. *Lens:* 50mm.

WORKING SOLO *(bottom)*

When shooting destination weddings, I often have to photograph them without Dawn (after all, someone had to stay home with Cade once he was too old to come with us). Therefore, I often have to do double duty. So when I am photographing the bride getting ready, I also have to run back and forth to get the men, too. It all comes down to planning and watching for the slow moments when I can move from room to room.

Exposure: f/2.8, $^1/_{640}$ second, ISO 1600. *Lens:* 17–55mm at 55mm.

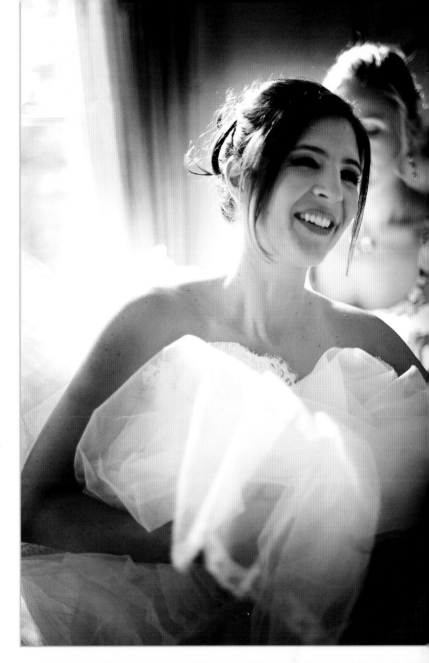

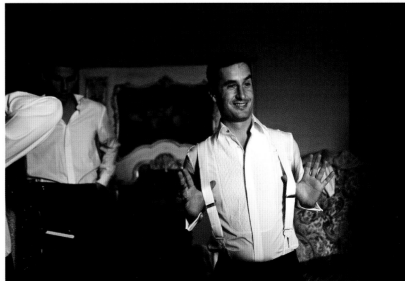

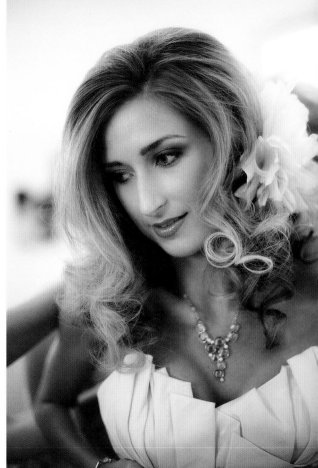

SELECTIVE FOCUS *(left)*

Trying to be as creative as possible during the getting-ready process is important to your clients. I have found that the more effort I put into the prep process, the more it gets my brain working for the rest of the day and makes for a truly unforgettable wedding.

For this image, I used a 50mm lens at f/1.4 so I could selectively show just the bride's face in the reflection as her makeup was being applied. This allowed me to include the makeup in the image but kept it from competing for the attention of the viewer.

Destination: France. *Exposure:* f/1.4, $^1/_{125}$ second, ISO 250. *Lens:* 50mm.

LENS SELECTION *(right)*

I hardly ever use anything but my 50mm when I am photographing the getting-ready images. I like being able to open up my aperture to f/1.4 and getting that beautiful shallow depth of field; and being able to shoot in almost no light isn't too shabby either! Many times, the rooms can feel a bit cramped, with all the people coming and going, so having a small lens can be an advantage. You might wonder why not use a wide lens for these shots? Truth is, I'm not a big fan of the distorted look you can get from a wide lens.

Exposure: f/1.4, $^1/_{320}$ second, ISO 1600. *Lens:* 50mm.

ONCE-IN-A-LIFETIME IMAGES (below)

Destination weddings can give you those once-in-a-lifetime images that no other photographer can produce, but to capture them, you have to be on your toes. The locations that you photograph in aren't ones that you are likely to have worked in before, so you always have to be on the lookout for opportunities and not drop your awareness. This image was from one of those times. I have had the great privilege to photograph in this venue many times, and I have seen many girls get ready in this room. The light was never more stunning than it was on this day though, so I opened up the window and just let the bride continue getting ready in front of it. It has become one of Dawn's most-loved images that I've created.

Exposure: f/2.8, $^1/_{500}$ second, ISO 400. *Lens:* 70–200mm at 70mm.

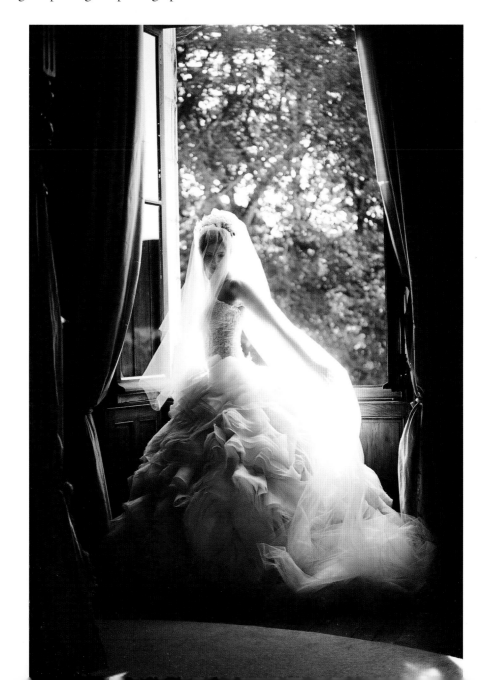

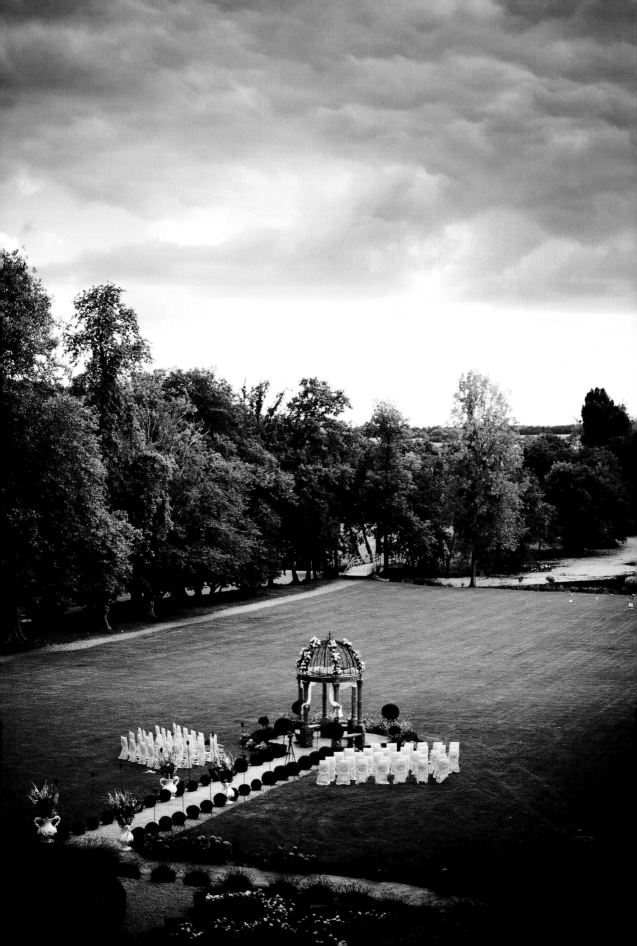

4 SETTING THE STAGE

FIND UNIQUE ANGLES *(previous page)*

Dawn is great about reminding me to always shoot at different angles. I fell into the trap of shooting in one spot over and over, after which she would say, "That looked great from over here." Now, when I shoot, I always try to ask myself how Dawn would photograph a moment.

When I was running through the gamut of décor images, it occurred to me that I had a vantage point that would allow me to get a photograph of the area from above. It was worth the effort of climbing the gazillion steps to get it, for the client and for me.

Exposure: f/1.4, ¹/₈₀₀₀ second, ISO 400. *Lens:* 50mm.

BRAVE THE WEATHER *(above)*

We have had a lot of experience photographing in adverse conditions. The big aspect to remember is to not let anything get you down. The night before this wedding, a tropical storm developed right off the coast of Jekyll Island, which is where Elizabeth and Chandler were getting married. They had planned to get married on the beach, but due to the weather, some people were trying to convince them to get married in the lobby of the hotel. I told the bride that she needed to get married on the beach anyway. After all, how many people can say they were married in a tropical storm?

Exposure: f/2.8, ¹/₇₅₀ second, ISO 400. *Lens:* 17–55mm at 31mm.

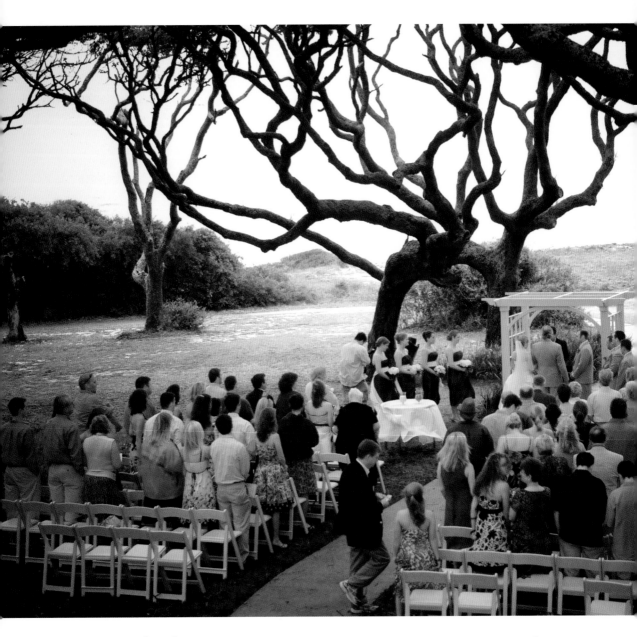

A SNEAK PEEK (above)

Though ceremony images are covered in a later section, I wanted to share this one here. As you can see, Elizabeth decided to get married on the beach. I wrapped my camera in a towel and ran into the storm. It was completely awesome, and I am glad it turned out the way it did. They did move the ceremony back from the beach a little bit so they wouldn't be right near the worst of the weather. Chandler and Elizabeth's maid of honor had to hold on to her veil so it wouldn't blow away. It was beautiful just the same.

Exposure: f/2.8, $^1/_{750}$ second, ISO 400. *Lens:* 17–55mm at 31mm.

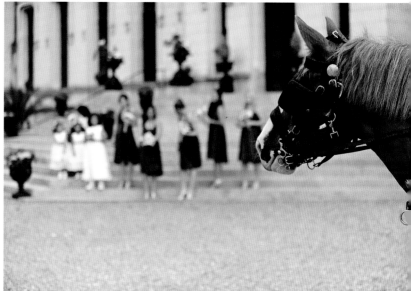

TELL A STORY *(above)*

The ladies of the wedding party and the horse were all wait-ing for the bride and her father to head over to the church across the street from this chateau. To add to the interest of this detail shot, I focused on the horse and threw the bridesmaids and flower girls out of focus with a shallow depth of field.

Exposure: f/2.8, $^1/_{1600}$ second, ISO 400. *Lens:* 70–200mm at 70mm.

"To add to the interest of this detail shot,
I focused on the horse and threw the bridesmaids and
flower girls out of focus with a shallow depth of field."

A LABOR OF LOVE *(following page, top)*

This is one of my favorite shots I've taken in my career. The ceremony was about to start and the bride was riding to the church in a horse and carriage. I really wanted to get a shot of her on her way to the church with the castle in the background, so I ran down the road as fast as I could so I could get into position and get the composition I wanted. It's a physical job being a wedding photographer!

Exposure: f/2.8, $^1/_{6400}$ second, ISO 200. *Lens:* 14–24mm at 24mm.

THE TELEPHOTO ADVANTAGE

(following page, bottom)

I caught this moment right before the ceremony took place. I used my 70–200mm lens so that I didn't have to be right on top of the subjects and I could achieve a nice shallow depth of field. I was able to focus on the man in the suit, but still get the energy in the image that comes from the man on the right who was laughing, without him being too distracting from the image itself.

Destination: France. *Camera:* Nikon D3. *Exposure:* f/2.8, $^1/_{400}$ second, ISO 800. *Lens:* 70–200mm at 180mm.

"I ran down the road as fast as I could so I could get into position and get the composition I wanted. It's a physical job being a wedding photographer!"

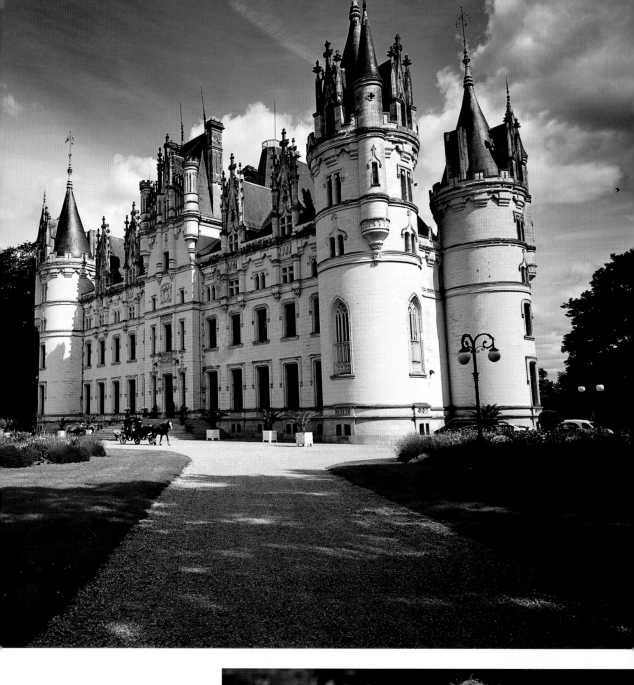

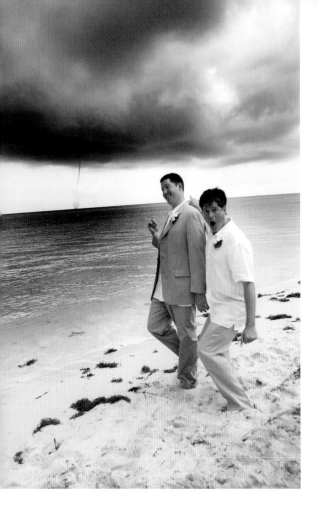

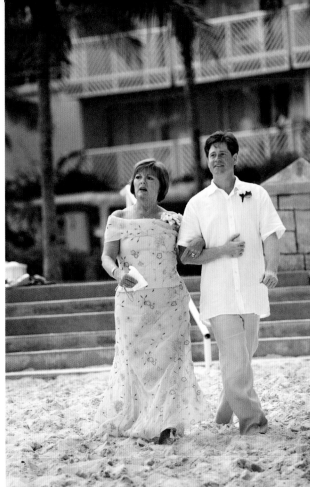

THE WATERSPOUT
(left and right)

You just never know what you will run into when shooting a wedding! We were in the Bahamas photographing a wedding and it was incredibly overcast and humid. The wedding was taking place on the beach and right behind the ceremony, a waterspout formed over the ocean. The first image is of the groom, Craig, with his groomsman. The second image is his mother's reaction as she was being walked down the aisle. What makes this even better is that the ceremony kept going on without a pause. I am normally terrified of weather like this, but you put a camera in my hand and, for some reason, it's snap, snap, snap. You can't stop a wedding, and what better story is there?

Destination: The Bahamas. *Exposure:* f/2.8, $^1/_{1250}$ second, ISO unknown. *Lens:* 17–55mm at 30mm.,

"I am normally terrified of weather like this, but you put a camera in my hand and, for some reason, it's snap, snap, snap."

A GRAND ENTRANCE (below)

Entering the ceremony, Aarti was being carried by her bridesmaids down the hallway of the MGM Grand in Detroit. Sometimes, the lighting conditions are not perfect and you have to do the best you can with what you are given at the moment. This was the case here. The group was illuminated by the overhead can lights and chandeliers, and I waited for them to walk by a window to take advantage of added side lighting.

Destination: Detroit, MI. *Exposure:* f/2.8, $^1/_{160}$ second, ISO 2500. *Camera:* Nikon D4. *Lens:* 70–200mm at 135mm.

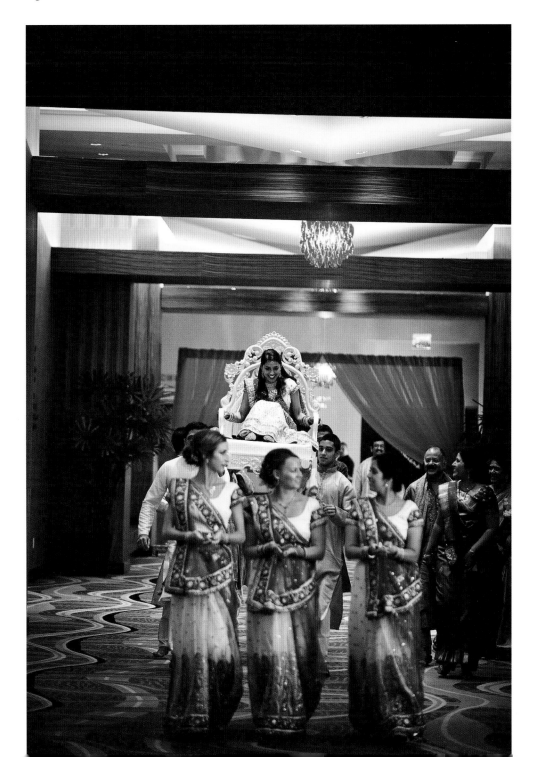

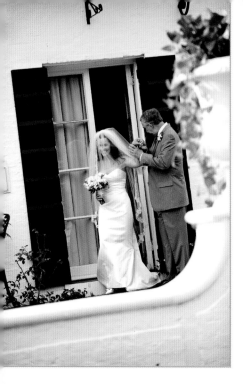

HERE COMES THE BRIDE
(above)

At the Jekyll Club Hotel, there are several venues at which a couple can have their wedding. At Crane Cottage, during the ceremony, the bride walks out of her room to walk down the aisle. This is where Anne's father met her to walk her down the aisle. I loved her expression.

Exposure: f/2.8, $^1/_{1600}$ second, ISO 400. *Lens:* 70–200mm at 135mm.

READY FOR ACTION *(right)*

Standing in the back of the aisle during the ceremony, I'm able to photograph the groom as he sees the bride for the first time, and I'm also able to capture the bride as she walks down the aisle. These last moments the bride spends with her dad before he gives her away are some of the most special of the wedding and are a must to capture, especially in these fantastic locations.

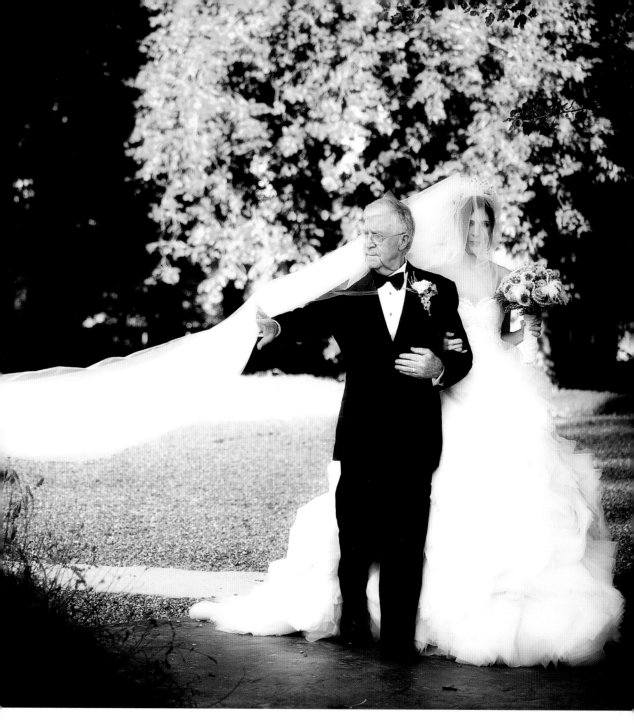

Exposure: f/2.8, $^{1}/_{1250}$ second, ISO 400.
Lens: 70–200mm at 70mm.

"These last moments the bride spends
with her dad before he gives her away are
some of the most special of the wedding . . ."

5 THE CEREMONY

BE FLEXIBLE (below)

I try to move around as much as I can during the ceremony to get all the best angles, rather than stay in one place and have all the images created from the same viewpoint. This gives the client a variety of images to view when they receive the finished product.

In this scenario, using a wide-angle lens allowed me to capture the ceremony, the castle, and even the setting sun in a single frame.

Exposure: f/2.8, $\frac{1}{25}$ second, ISO 400. *Lens:* 14–24mm at 14mm.

"Using a wide-angle lens allowed me to capture the ceremony, the castle, and even the setting sun in a single frame."

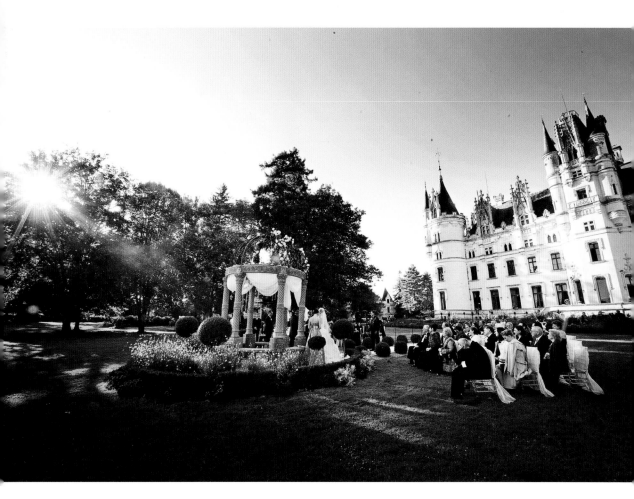

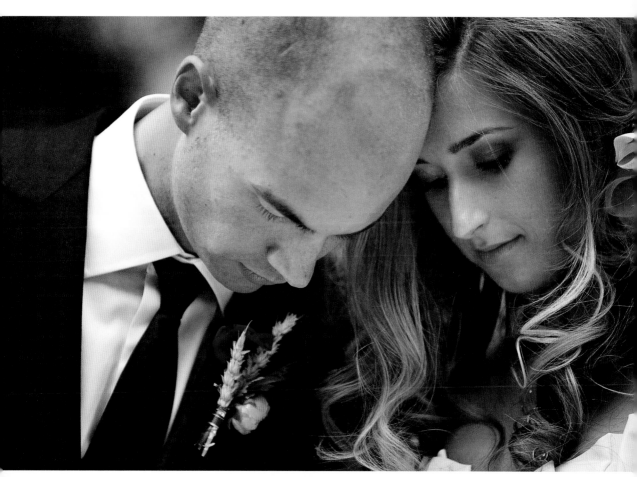

AN INTIMATE MOMENT (above)

This is one of the bride and groom's favorite images from their wedding. It was taken during the prayer at the ceremony. Their legal ceremony took place in a courthouse in France, but the religious ceremony took place outdoors at the Chateau Grand Boise. Since it was outside, I didn't feel it was bad to move around and get more intimate images. Even though I was moving around, I used my zoom lens so I wouldn't be right up in their faces. When the minister started the prayer, I saw Willy lean in and touch his head to Ginger's. I knew that was the moment I wanted to capture for them.

Destination: France. *Exposure:* f/2.8, $^1/_{400}$ second, ISO 800. *Camera:* Nikon D3. *Lens:* 70–200mm at 200mm.

"This is one of the bride and groom's favorite images from their wedding. It was taken during the prayer at the ceremony."

MINIMIZE THE BACKGROUND (previous page)

No matter how beautiful the destination, sometimes you get stuck in a situation where you are forced to photograph in a place that isn't as visually stunning as the rest of the property or location. In these situations, the best thing to do is to minimize what is showing in the background. I chose my 70–200mm lens in this case so I could get in close and eliminate any distractions that I could see.

Exposure: f/2.8, $^1/_{60}$ second, ISO 1600. *Camera:* Nikon D4. *Lens:* 70–200mm at 170mm.

A SENSE OF PLACE (below)

Sometimes you will get one chance at these locations, so if there is a shot you want to capture, just go for it. I wanted to be down there with the ceremony, but I couldn't pass up this opportunity to include the ruins in the image as well. I had to sprint from where the ceremony was taking place to this overlook so I could get this image. Why not have a second shooter? Well, sometimes it's just not possible to have someone with you and you have to make the best of it alone.

Destination: Germany. *Exposure:* f/2.8, $^1/_{2500}$ second, ISO 125. *Camera:* Nikon D4. *Lens:* 14–24mm at 14mm.

> "Sometimes you will get one chance at these locations, so if there is a shot you want to capture, just go for it."

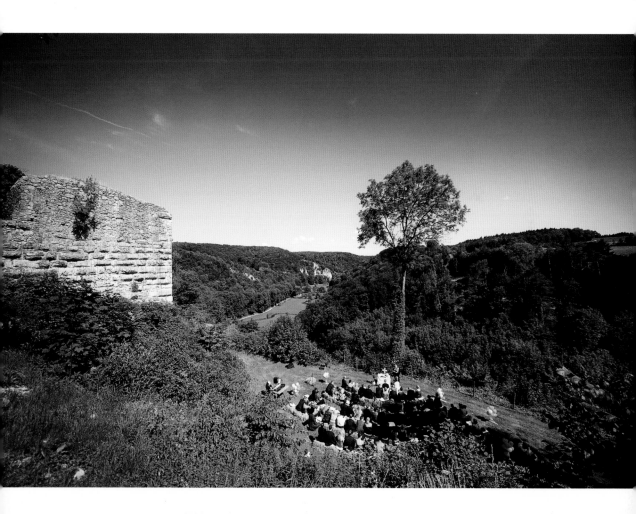

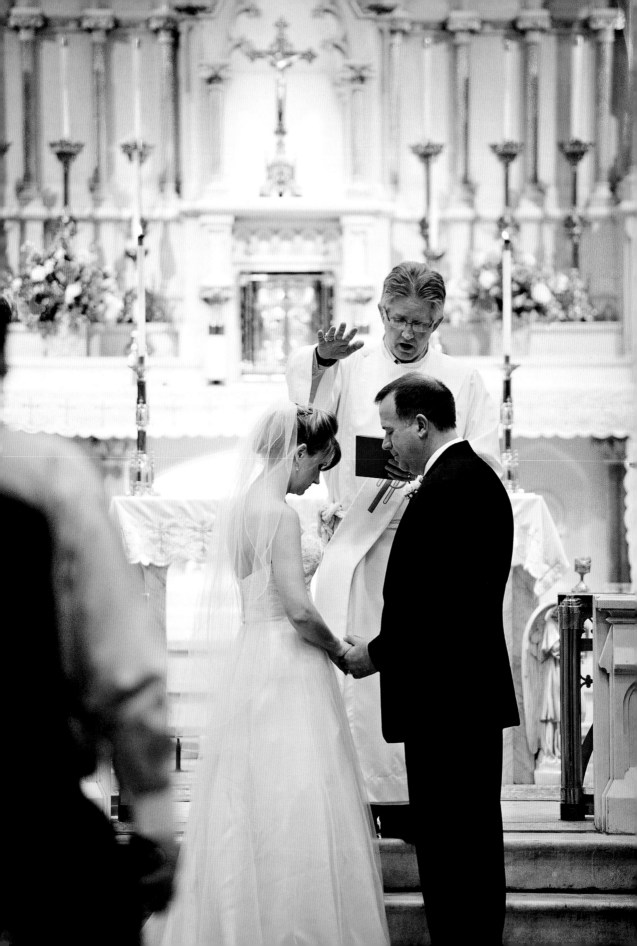

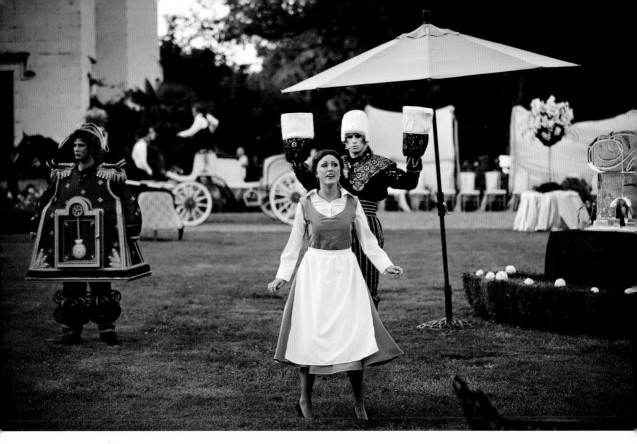

CHURCH CEREMONIES *(previous page)*

We photographed this wedding in Jacksonville, FL, at a cathedral. I am always hesitant to run up and down the aisles at a church—it's a good way to be asked not to come back! This is why we carry the big lenses, so that we can shoot down to the front of the church without having to be in anyone's way. In this instance, I used the maximum zoom for my lens and the available light that came from the altar. I never use flash during a ceremony, as it draws too much attention to the photographer.

Destination: Jacksonville, FL. *Exposure:* f/2.8, ¹⁄₁₀₀ second, ISO 1000. *Camera:* Nikon D4. *Lens:* 70–200mm at 200mm.

A ONE-OF-A-KIND WEDDING *(above)*

One of the most interesting weddings I have ever photographed was what we call the *Beauty and the Beast* wedding. A couple from Russia had a theater group from England come over and perform Beauty and the Beast, the musical, throughout the wedding, complete with costumes, sets, and props! It was breathtaking. It seemed as though I never stopped shooting at all, there was so much going on at this event. Again, here, I shot with my aperture wide open to separate the actors from the background to add drama to the scene.

Destination: France. *Exposure:* f/2.8, ¹⁄₄₀₀ second, ISO 250. *Camera:* Nikon D4. *Lens:* 70–200mm at 102mm.

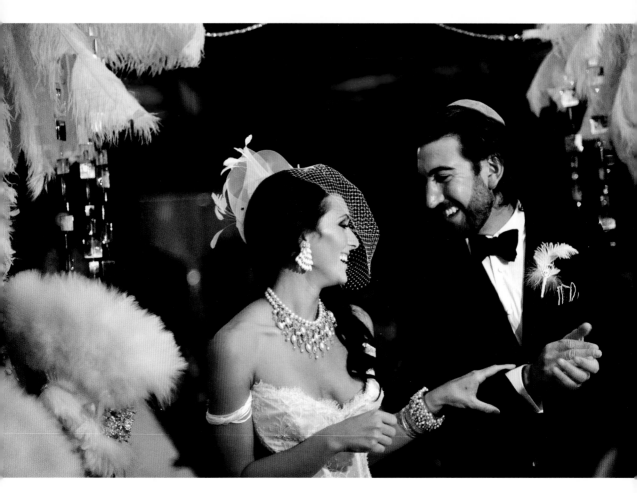

AN ELEGANT CEREMONY (*above*)

One of the most beautiful ceremonies I have ever photographed was at the Temple Emanu-El in Miami. It was a very large temple, and I wanted to get in close to the chuppa. I put my 50mm f/1.4 lens on my camera and moved in close. Using only the available light from the spotlights that were shining on the couple, I photographed this image of the two of them.

Destination: Miami, FL. *Exposure:* f/1.4, $^{1}/_{250}$ second, ISO 400. *Lens:* 50mm.

"One of the most beautiful ceremonies I have ever photographed was at the Temple Emanu-El in Miami."

A PRIVATE WEDDING (below)

Here we find ourselves in Costa Rica with a couple who decided to get married on a mountain. Dawn and I were the only guests for this wedding, so we acted as photographers and witnesses at the same time! The couple had decided at the last minute to cancel the wedding that they planned in the States and get married in Costa Rica, where they were planning their honeymoon. So, a few weeks later, Dawn and I were standing beside them as they said their vows.

Destination: Playa de Conchal, Costa Rica. *Exposure:* f/2.8, 1/500 second, ISO 400. *Lens:* 17–55mm at 26mm.

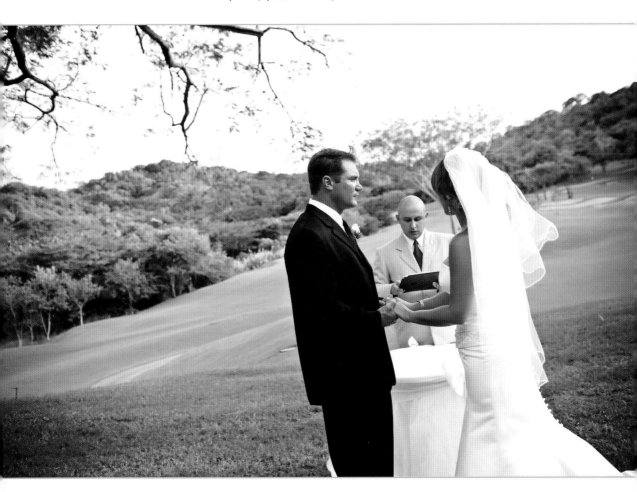

"Dawn and I were the only guests for this wedding, so we acted as photographers and witnesses at the same time!"

A SENSE OF FREEDOM (below)

One of the things that I love about photographing most of the destination weddings that we have done is that there aren't as many restrictions when it comes to photographing the ceremony. Photographers should still not make a nuisance of themselves, but having a little more freedom to move around is a good thing. I use long lenses and I try and move quickly and quietly so as not to make myself the center of attention and distract from the bride and groom.

Exposure: f/2.8, $\frac{1}{1250}$ second, ISO 400. *Lens:* 17–55mm at 17mm.

SUNRISE WEDDING (following page)

Emily and Zach wanted a wedding on the beach at sunrise. It was a beautiful vision, to be sure, but it was a logistical nightmare for the people who were getting ready. We got into Cocoa Beach the night be-fore the wedding. The girls started getting ready around 2:00 in the morning, and we started photographing at about 5:00AM, if I remember correctly. As the sun came up and the ceremony started, the scene was breathtaking. It was a very early morning, but it was completely worth getting up for the sunrise.

Exposure: f/2.8, $\frac{1}{3200}$ second, ISO 160. *Lens:* 17–55mm at 17mm.

"One of the things that I love about photographing most of the destination weddings that we have done is that there aren't as many restrictions when it comes to photographing the ceremony."

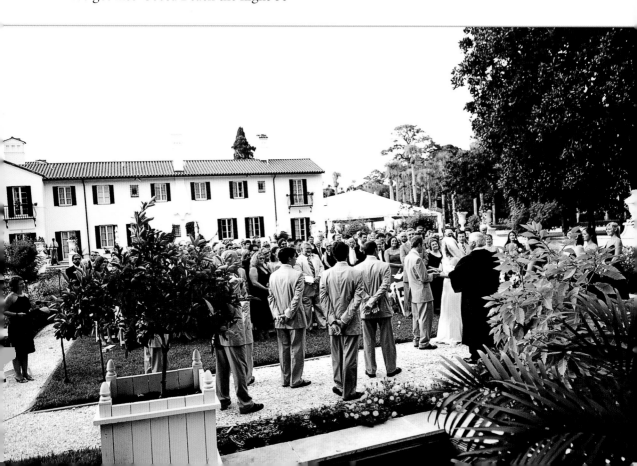

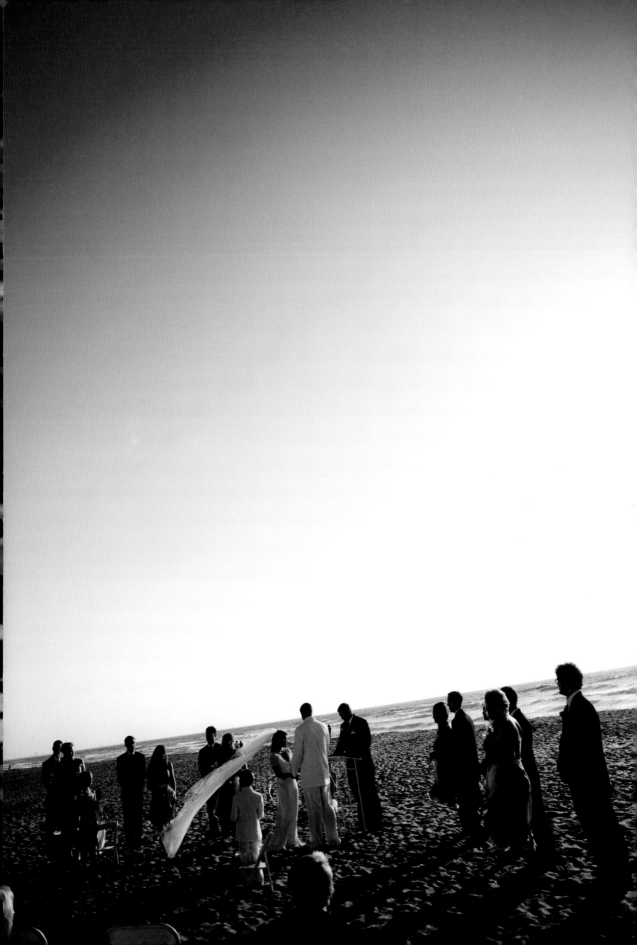

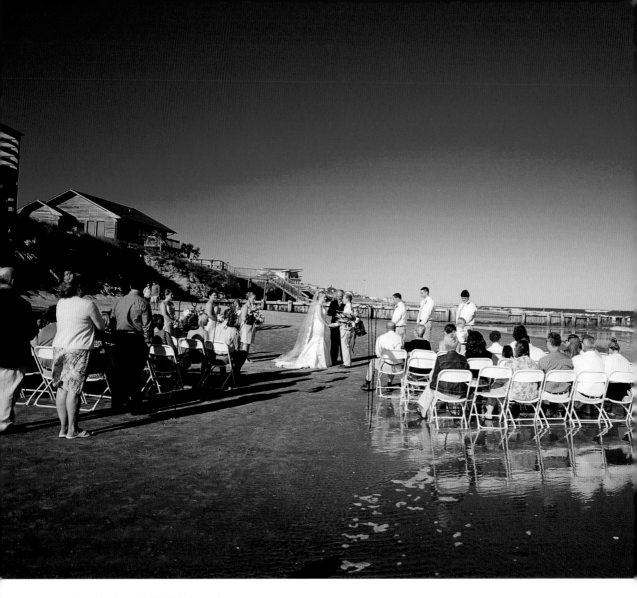

READY FOR ANYTHING (above)

Before Stephanie's wedding in South Carolina, there was a hurricane that did quite a bit of damage to the beaches and surrounding areas. So the ceremony was delayed. The tide started coming in on the ceremony site. On account of the storm, the tide moved very fast, so the minister started to speed up the ceremony. Before the ceremony ended, more than half of the guests were sitting in the water!

Destination: South Carolina. *Exposure:* f/2.8, $^{1}/_{6400}$ second, ISO 200. *Lens:* 14–24mm at 24mm.

THE EXIT (following page, right)

All the guests threw flower petals as Lindsey and Ludwig left the church in France. I didn't have a lot of room to get the overall shot that I wanted and I couldn't back up any farther because a horse and carriage was blocking my way. The only choice I had was to get in the carriage and shoot from there.

"The sun was coming in from behind the carriage, casting a shadow on the guests at the bottom of the frame, giving a nice vignette to the image."

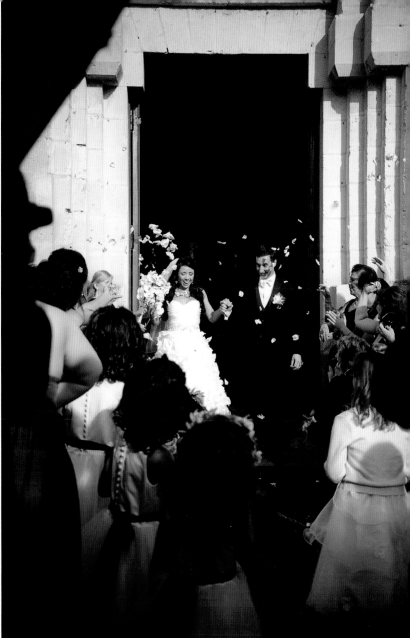

The sun was coming in from behind the carriage, casting a shadow on the guests at the bottom of the frame, giving a nice vignette to the image.

Exposure: f/2.8, $^1/_{5000}$ second, ISO 500. *Lens:* 17–55mm at 40mm.

A MAGICAL MOMENT (right)

This is another of my favorite images. There are several moments that take place around and during the ceremony that I feel are special, and this was one of those moments. After Mila and Vladmir said their vows (which were spoken in Russian), they walked back down the aisle. On their way, the groom stopped and brought his bride's hand to his lips. With my aperture wide open, I was able to create a shallow depth of field that allowed me to separate the subjects from the background and guests. The resulting image has a fairytale look. The moment was over in a split second. If I'd put the camera down or let it hang on my neck, I would have missed my opportunity to capture this tender moment. This is the reason why I do not wear a camera strap, the camera always has to stay in my hand.

Destination: France. *Exposure:* f/2.8, $^{1}/_{2500}$ second, ISO 250. *Camera:* Nikon D4. *Lens:* 70–200mm at 102mm.

NEVER STOP SHOOTING (following page, bottom)

It is important to always be on the lookout for the next image. After the ceremony was over, Brandi and Justin were ushered through a door to the side of the church. I ran around the side and was greeted with this great scene of them in a special post-ceremony moment. Never put your camera down and never stop shooting. You just might miss something.

Exposure: f/2.8, $^{1}/_{250}$ second, ISO 400. *Lens:* 70–200mm at 70mm.

"Never put your camera down and
never stop shooting.
You just might miss something."

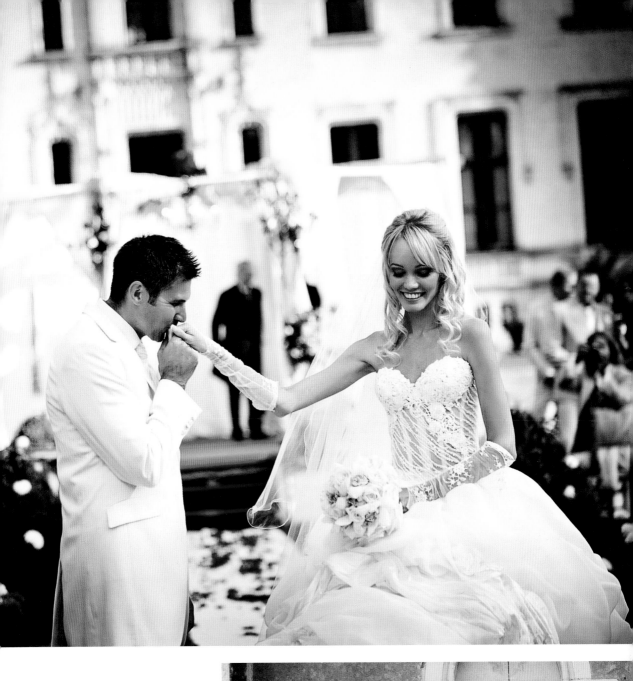
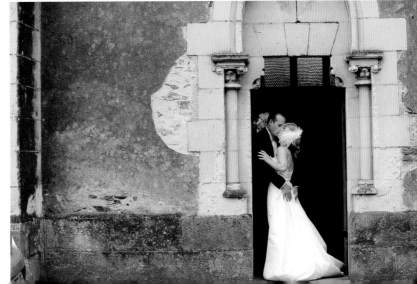

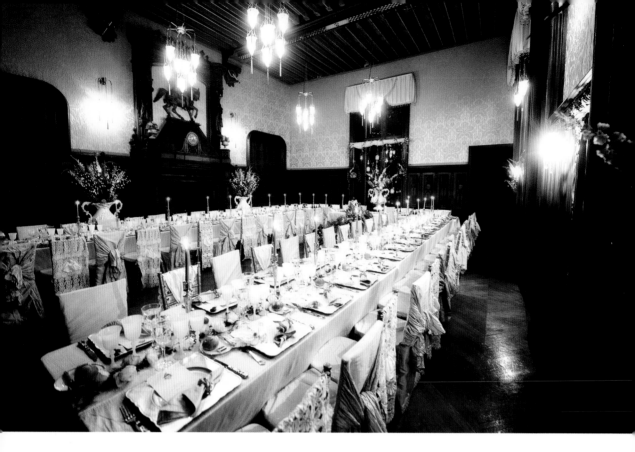

6 THE RECEPTION

GET TO KNOW THE VENDORS *(above)*

The more effort you put into getting to know your vendors, the better off you will be. I have a pretty good relationship with the owner of this venue in France, so they always go out of their way to make sure we get images of the setup and decorations. Our relationship benefits them, as well.

I wanted to show the ambiance of the room, so I decided to work with the available light. I exposed for $^1/_{40}$ second at ISO 2000. I did end up picking up some window light on the chair (note the bluish tint on the chairs in the front), but overall, I feel I captured a pleasing image.

Exposure: f/2.8, $^1/_{40}$ second, ISO 2000. *Lens:* 14–24mm at 15mm.

> "I wanted to show the ambiance of the room, so I decided to work with the available light."

THE DETAILS (below)

Getting great images of the wedding details is essential.
What has worked the best for me is making friends with
the wedding planner and event owners; they are essential
to helping me have a chance to photograph the rooms and
decorations without the crowds. Detail shots are just as im-
portant to the venues as they are to the bride and groom—
especially when you are working at a destination venue.
These venues often see many vendors who don't come back
and don't send room shots to them. When I photograph at
these venues, I always send images and albums. By doing so,
I make friends with the planners and owners and earn lots of
referrals for more weddings.

Exposure: f/3.5, $^1/_{30}$ second, ISO 400. *Lens:* 17–55mm at
38mm.

"When I photograph at these venues, I always send images and albums. By doing so, I make friends with the planners and owners and earn lots of referrals for more weddings."

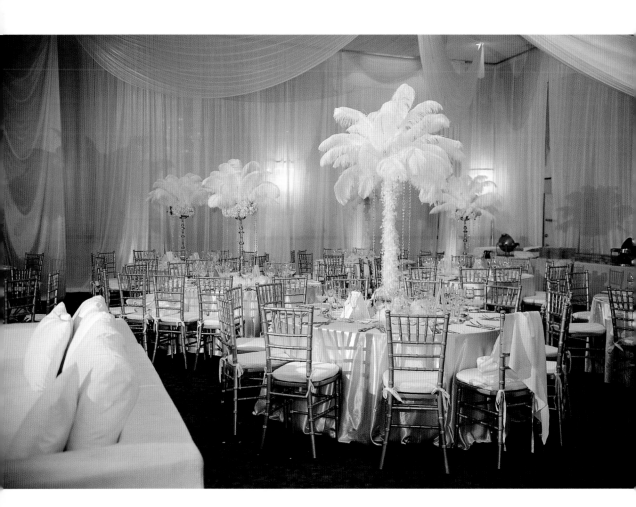

HANDHELD EXPOSURES *(following page, top)*

When photographing a wedding, I do not use a camera strap. I hold the camera in my hand the entire time, and I have a very good reason for doing this. Let's say there is a moment during the day when there is not much going on, so you let the camera hang around your neck or on your shoulder. All of a sudden, the bride decides that she is going to fake out her bridesmaids by acting like she is going to throw her bouquet. While another photographer is frantically trying to get the camera back into their hands and up to their face, I lift my hand and press the shutter button. Also, the only time I used a strap, I caught it on a chair during the reception and it was yanked from my hand, shattering my lens. No camera straps for me!

Destination: France. *Exposure:* f/2.8, $^1/_{125}$ second, ISO 640. *Lens:* 17–55mm at 45mm.

> "The only time I used a strap, I caught it on a chair during the reception and it was yanked from my hand, shattering my lens. No camera straps for me!"

SEALED WITH A KISS *(below)*

Heather and Stephen were married at the Jekyll Island Club in Jekyll Island, GA. On this island at the time was a guy who, according to locals, had built his own airplane. I had to make a quick decision to get the plane in the image, so I stopped down my aperture to get the best-possible image of the sun and the couple in silhouette, as well as the airplane, and fired away. For an added cuteness factor, I asked the couple to kiss.

Destination: Jeckyll Island, GA. *Exposure:* f/22, $^1/_{100}$ second, ISO 400. *Lens:* 17–55mm at 17mm.

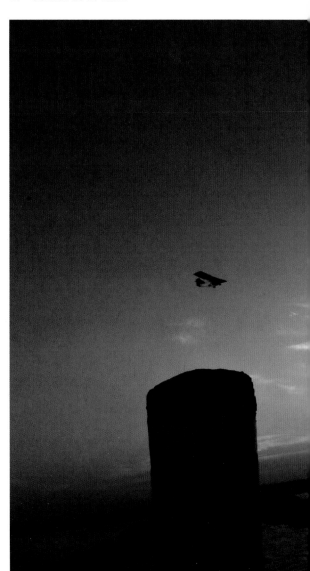

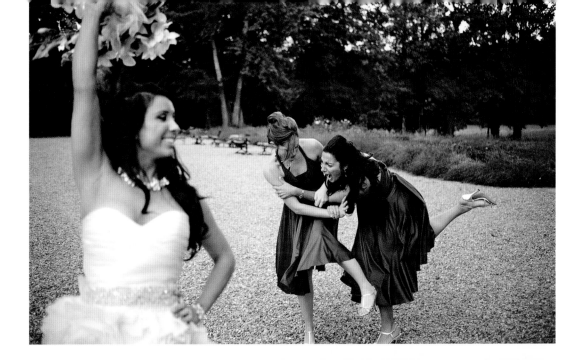

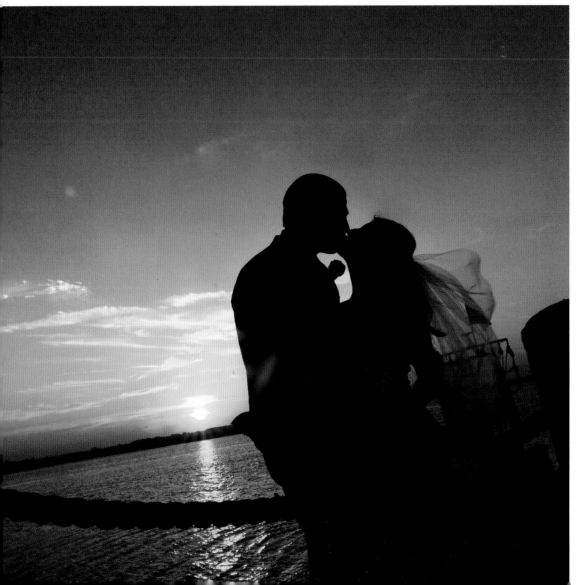

CANDID MOMENTS *(below)*

Weddings, whether they are in your town or across the ocean, come down to moments. Random beautiful moments can take wedding images from normal to art! In this case, the bride was standing there, just talking to her bridesmaids during the cocktail hour, and I was there ready with my camera, just in case. With a little gust of wind and a click of the shutter, I was able to document a moment that still takes my breath away.

Destination: France. *Exposure:* f/2.8, $\frac{1}{640}$ second, ISO 400. *Lens:* 70–200mm at 70mm.

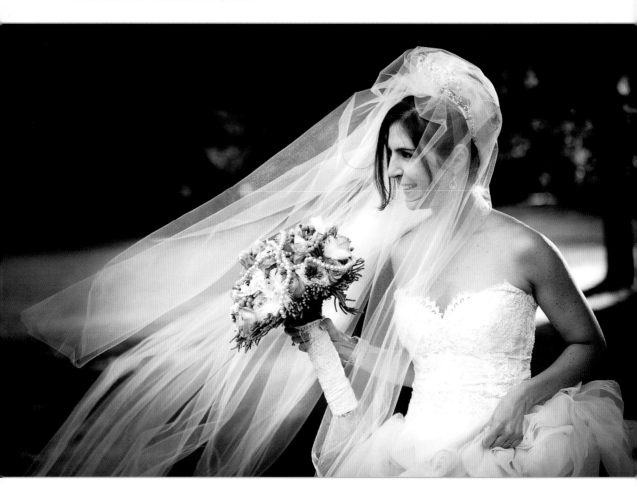

"With a little gust of wind and a click of the shutter, I was able to document a moment that still takes my breath away."

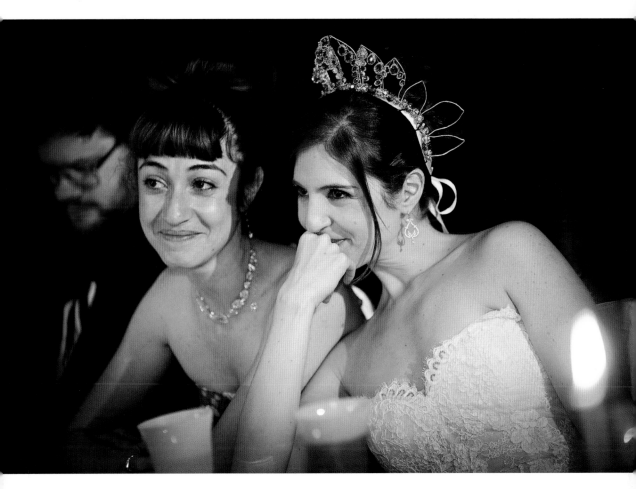

SPEEDLIGHTS (above)

While photographing the speeches, dances, and most of the important moments throughout a reception, I do rely on speedlights. They are my preferred method of adding light, as they are lightweight and do not take up much room in my luggage. I set the speedlights up so that I have one on a stand (the main light, which is placed at a 45-degree angle to my camera) and one on my camera (the fill). Using that setup, I photographed this image of the bride and her sister enjoying a moment together during the speeches. I love this image, because you can almost feel the emotion ebbing from them and it's echoed in the tears starting to form in the bride's sister's eyes.

Exposure: f/2.8, $\frac{1}{50}$ second, ISO 800. *Lens:* 70–200mm at 160mm.

"I set the speedlights up so that I have one on a stand (the main light, which is placed at a 45-degree angle to my camera) and one on my camera (the fill)."

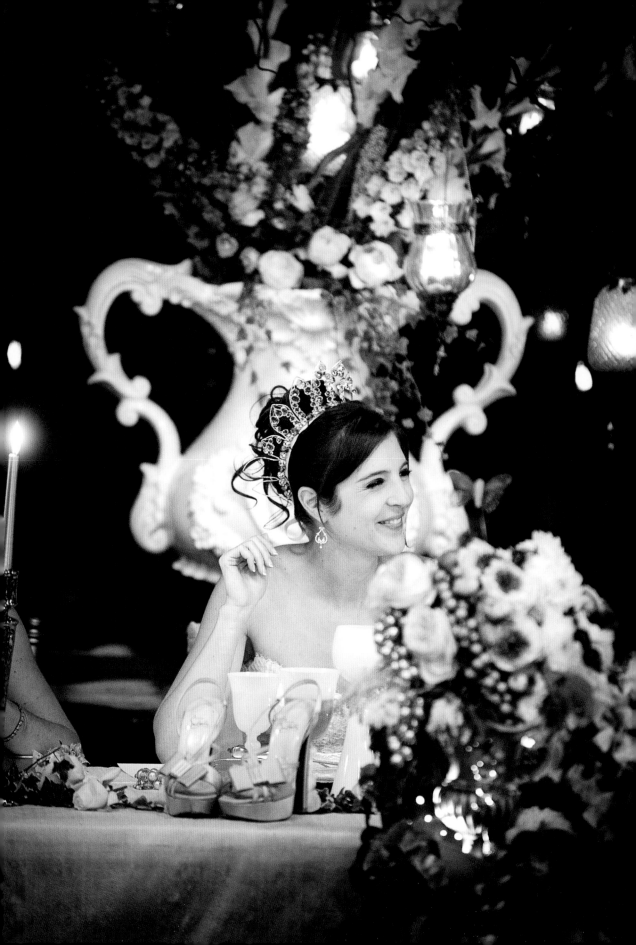

CANDLELIGHT (previous page)

I photographed this image across the room by candlelight. I like to try and find moments when I don't have to interrupt the emotion and feel of the day. During this particular reception they had quite a bit of candlelight, so I turned off my speedlight and photographed solely by the light that was available to me.

Exposure: f/2.8, $^1/_{40}$ second, ISO 3200. *Lens:* 70–200mm at 200mm.

BE PREPARED (below)

So often, you will be put into a position that you weren't able to prepare for. As such, it's always a good idea to over-pack for weddings so that you are prepared for whatever might take place or whatever location you might end up photographing in. In this castle, the hallway in which the dancing took place was relatively small. I needed a wide lens to be able to get the entire scene for this image. As it happened, I had packed the lens, just in case.

Exposure: f/2.8, $^1/_{100}$ second, ISO 2500. *Lens:* 14–24mm at 18mm.

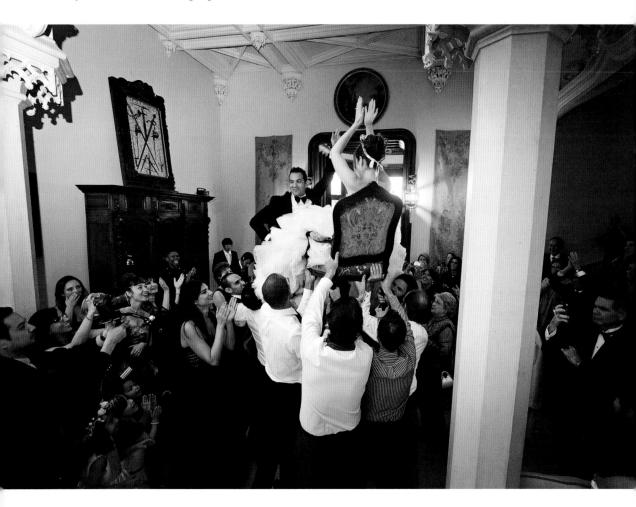

DOCUMENTING THE EMOTION (above)

When I am photographing receptions, I love the moments and expressions that the bride and groom share when they are listening to the speeches and toasts. I try to position myself somewhere between the person giving the speeches and where I can see the bride and groom. This way I can avoid moving too much and drawing too much attention to myself.

Exposure: f/2.8, $^1/_{100}$ second, ISO 2500. *Camera:* Nikon D3. *Lens:* 17–55mm at 38mm.

PREPARATION IS KEY (following page)

For a lot of wedding photographers, preparation is key to a successfully photographed wedding. Knowing where to photograph from and where to place your lighting can make a big difference in your images. When photographing a destination wedding, you are not typically photographing in a location that you have been able to scout out and are often working with less equipment. I carry a GorillaPod when I travel. I put a flash on it and I can attach it almost anywhere. In this case, I attached one to the side of a cabinet so I could use multiple flashes during the dancing. I set an off-camera flash as my main light and used the flash on my camera as fill.

Exposure: f/1.4, $^1/_{80}$ second, ISO 1000. *Lens:* 50mm.

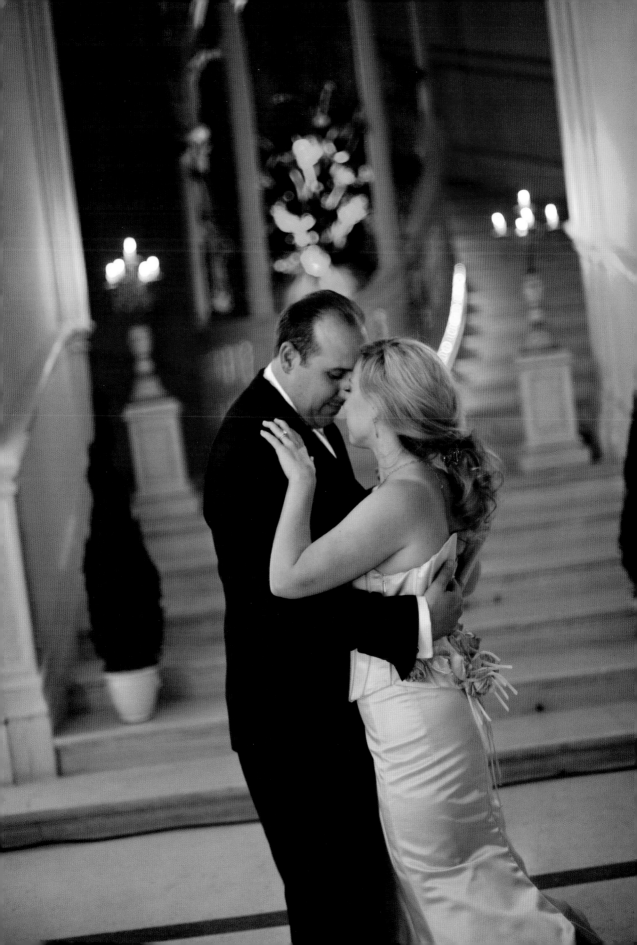

OUR TWO-FLASH SYSTEM
(right)

For this image, Dawn was
standing off to the left with
a flash set to slave mode. I
had the master flash on my
camera. We were photo-
graphing the dancing that
was taking place, and Ashley
and Josh got on the couch
and really started going
crazy.

When we are in recep-
tions, we use a two-flash
system, always having one
about 45 degrees from the
camera. At the time we
were shooting this wedding,
we were using the Nikon
Advanced Wireless System
where the flashes talk to
each other. Now, we use
RadioPoppers to trigger our
flashes.

Destination: Miami,
FL. *Exposure:* f/2.8, $^1/_{125}$
second, ISO 2000. *Lens:*
17–55mm at 24mm.

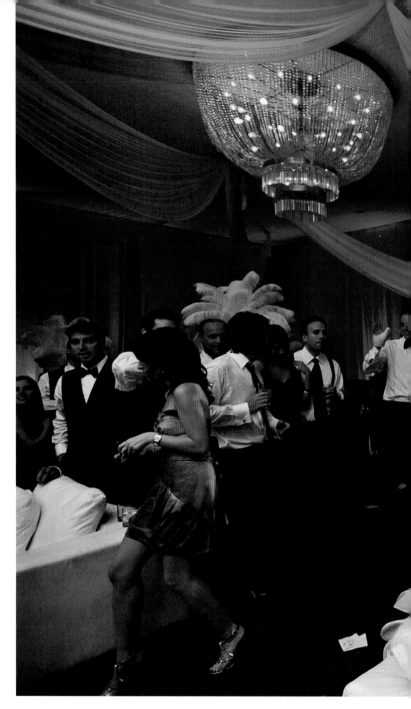

A VENEZUELAN TRADITION
(following page, bottom)

Somewhere in the dwin-
dling hours of this recep-
tion for Ana Carolina and Gabriel, masks
and all sorts of hats were dropped from the
second floor of the chateau. The couple
told me that this was one of the traditions
for a Venezuelan wedding celebration. It
was incredible. Everyone was having so
much fun, and we were able to make some
beautiful images of the guests and wedding
party alike.

Destination: France. *Exposure:* f/2.8,
$^1/_{40}$ second, ISO 400. *Lens:* 17–35mm at
23mm.

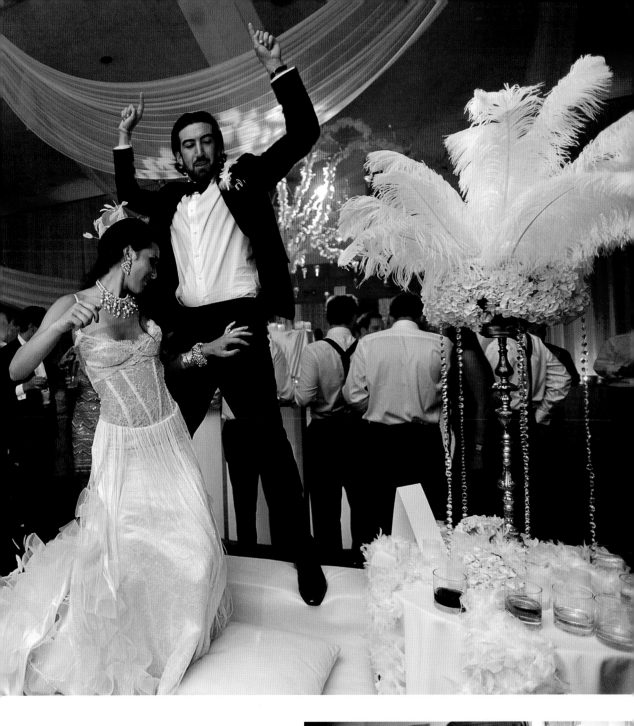
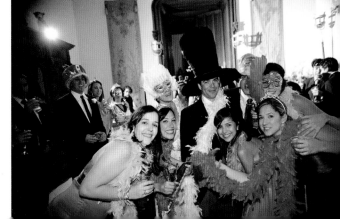

7 PICTURESQUE LOCATIONS

SEEK PERMISSION (below)

On our way back from creating some images in a field of flowers, we passed by this house with all of this beautiful wisteria covering the front. Before you photograph on private property, be sure to get the owner's permission to shoot. The last thing you want to do is to get the venue in hot water with the locals and ruin any chance that you might have to be referred for future weddings.

Destination: France. *Exposure:* f/2.8, $^{1}/_{60}$ second, ISO 400. *Lens:* 70–200mm at 70mm.

"Before you photograph on private property, be sure to get the owner's permission to shoot."

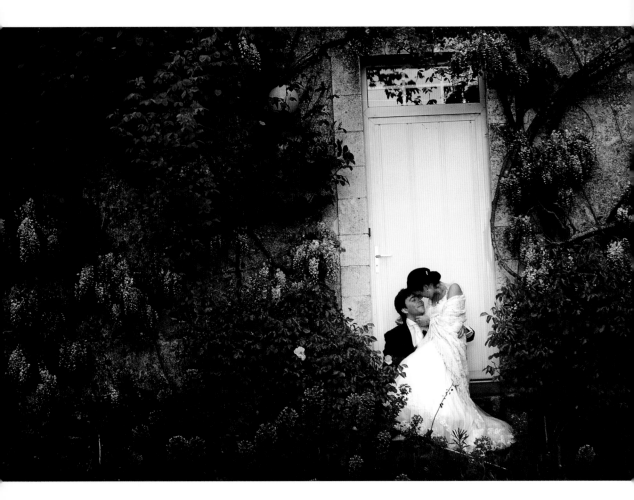

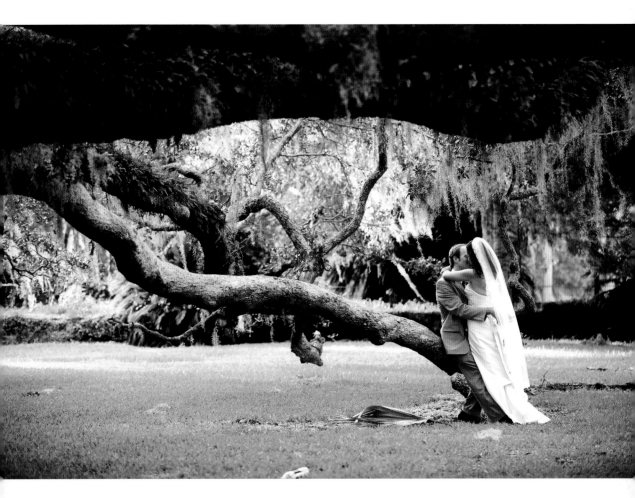

MEANINGFUL PLACES *(above)*

When I photograph anywhere, whether it's in Paris or in my own hometown, I always ask my clients why they wanted to have pictures made in the specific location. I then try to incorporate that aspect into the photos that we create for them. In this case, there are these very old and regal oak trees all over the Jekyll Club Hotel grounds, and the couple wanted them in their images.

Destination: Jeckyll Island, GA. *Exposure:* f/2.8, $^1/_{250}$ second, ISO 800. *Lens:* 70–200mm at 116mm.

"When I photograph anywhere, whether it's in Paris or in my own hometown, I always ask my clients why they wanted to have pictures made in the specific location."

THE BIG PICTURE (below)

There was an amazing group of vines on the side of this chateau. I wanted to create an image that showed off the foliage, but showcased the bride as well. I had the bride stand in front of the blue door to help separate her from the wall and the vines. I used my 17–35mm lens at 35mm to minimize the distortion that can result with a wide lens. I am not a big fan of lens distortion. I believe that it can be a gimmick that can be used too much, especially at a wedding.

Destination: France. *Exposure:* f/2.8, $\frac{1}{500}$ second, ISO 800. *Camera:* Nikon D3. *Lens:* 17–35mm at 35mm.

A SLICE OF LIFE (following page)

Just across from the courthouse where this couple's ceremony was held, there was this great wall with the traditional yellow mailbox that you see in France. I couldn't resist shooting there.

Normally, with most of my images, my first thought is always about the bride. After posing the bride and shooting some images of her, I added Willy. I simply had him lean back on the mailbox. I've never been afraid to let life work its way into wedding images, so when this boy walked past the couple, staring, I shot away.

Destination: France. *Exposure:* f/2.8, $\frac{1}{2500}$ second, ISO 800. *Lens:* 17–35mm at 26mm.

> "I've never been afraid to let life work its way into wedding images, so when this boy walked past the couple, staring, I shot away."

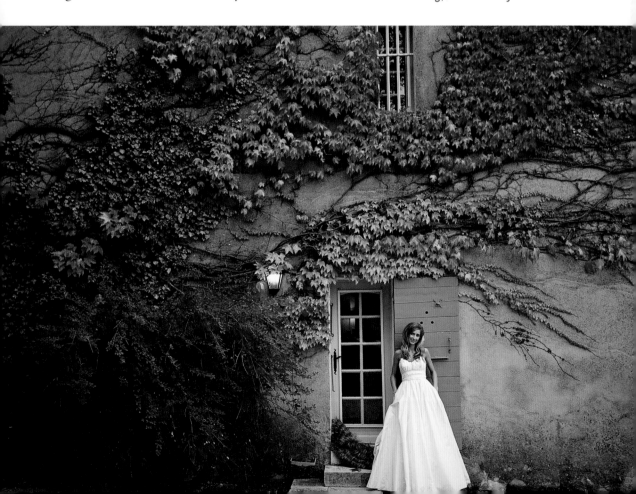

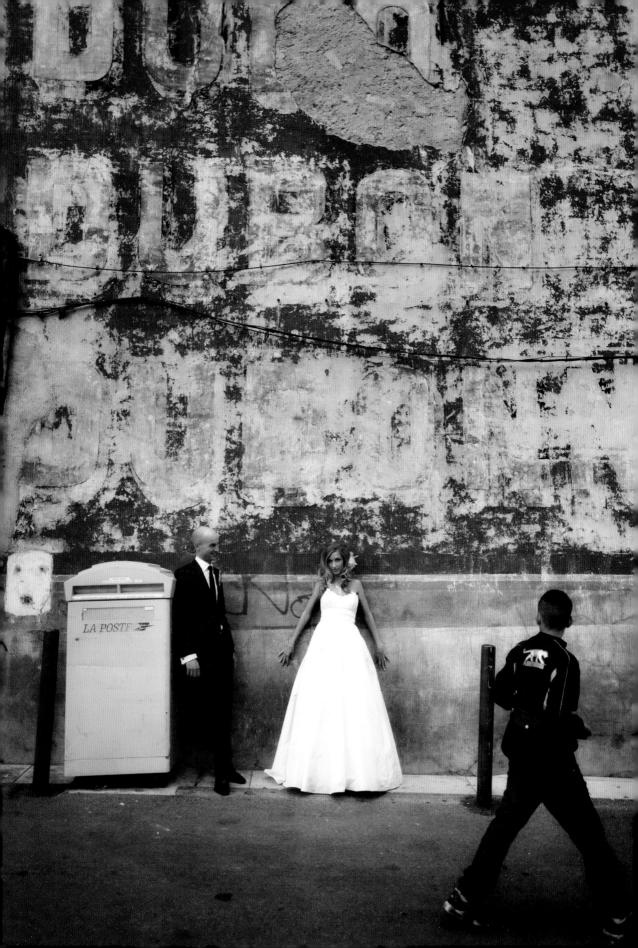

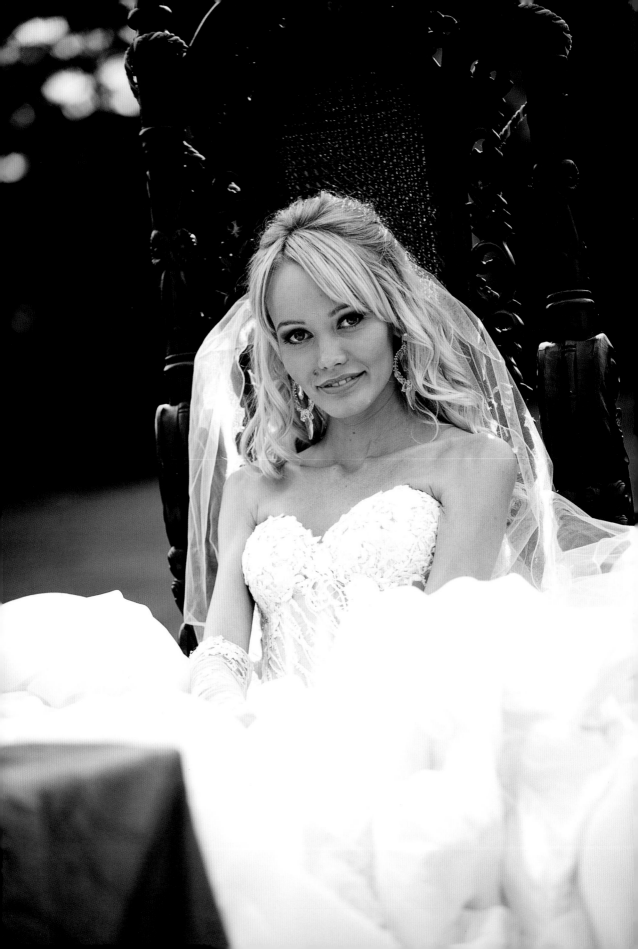

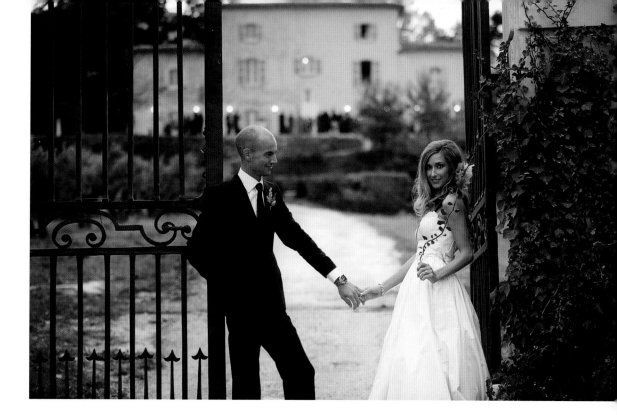

PURE ELEGANCE *(previous page)*

Always be on the lookout for spontaneous beautiful moments. I never put my camera down at a wedding; I don't even have it on a strap, because it is far too tempting to let it hang off my neck. Not having a strap means that my camera is always in my hand, and I am ready to shoot at any moment. Such was the case here; Mila had sat down at a table to catch a break from the day's events. The light was too pretty to pass up, so I kept shooting. Those candid moments made for some elegant bridal portraits.

Destination: France. *Exposure:* f/2.8, $^1/_{1250}$ second, ISO 250. *Camera:* Nikon D4. *Lens:* 70–200mm at 105mm.

PEOPLE-PLEASING IMAGES *(above)*

I tell people all the time that when you are shooting a wedding, you don't just have one client, but many clients. One of the best marketing tactics is to capture images that both your clients and the vendors will love. Make sure the vendors get the images so they can use them for their own marketing efforts. Often, I will ask vendors if there are any special images they would like for me to take for them.

Destination: France. *Exposure:* f/2.8, $^1/_{160}$ second, ISO 800. *Camera:* Nikon D3. *Lens:* 70–200mm at 95mm.

" . . . capture images that both your clients and the vendors will love. Make sure the vendors get the images so they can use them for their own marketing efforts."

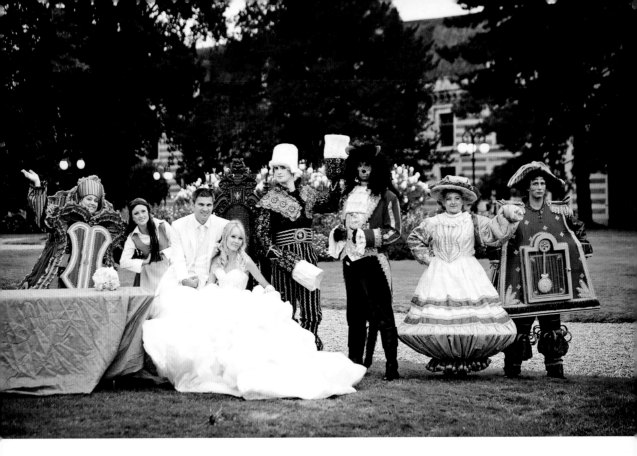

THE ENSEMBLE *(above)*

Here is a shot we took of the bride and groom with the entire cast of *Beauty and the Beast*. The couple, from Russia, was having their wedding at a castle in France, and they had a theater group from England come in and perform the musical *Beauty and the Beast* throughout the entire wedding. The morning of the wedding, I woke up to the sound of the group rehearsing on the lawn of the chateau. It was incredible.

Destination: France. *Exposure:* f/2.8, ¹/₅₀ second, ISO 250. *Camera:* Nikon D3. *Lens:* 70–200mm at 70mm.

TIMING IS EVERYTHING *(following page)*

Timing is crirical when photographing outdoors at night. There is a small window, measured in minutes, when photographing outside at night is beautiful. It's as simple as gorgeous image one minute, ten minutes pass, and now you have an image with a lot of black sky. Be pushy and educate your clients that when you say it's time to go, you mean it's time to go. You do not mean it's time to say hi to everyone they pass by on their way out of the building. With this image, Dawn was on camera right with a video light. I set the ISO to 2000 and used an aperture of f/2.8 to let in as much light as I could. I set the white balance to tungsten to ensure the available light was rendered with a beautiful blue hue.

Destination: Detroit, MI. *Exposure:* f/2.8, ¹/₁₀₀ second, ISO 2000. *Camera:* Nikon D4. *Lens:* 50mm.

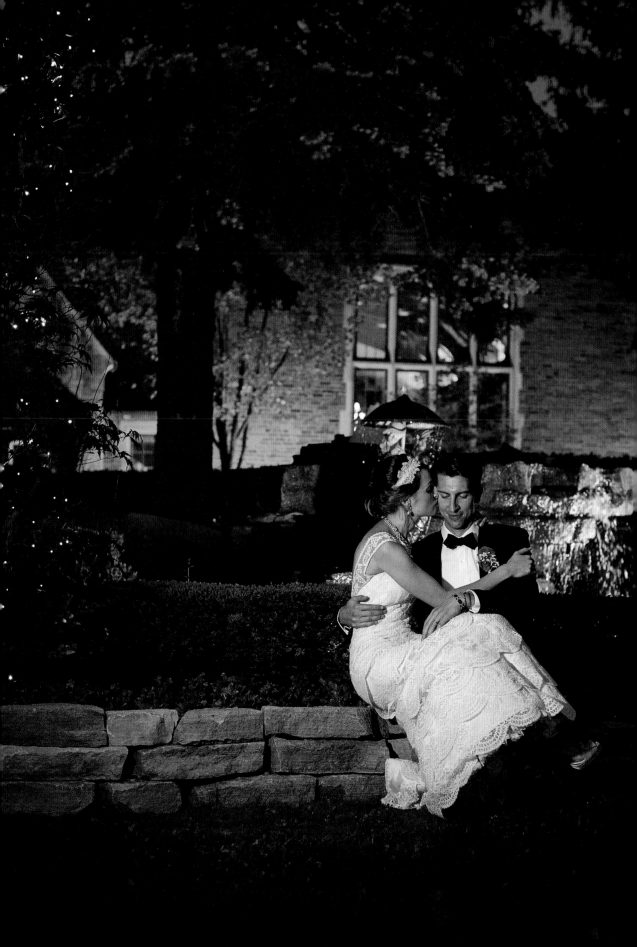

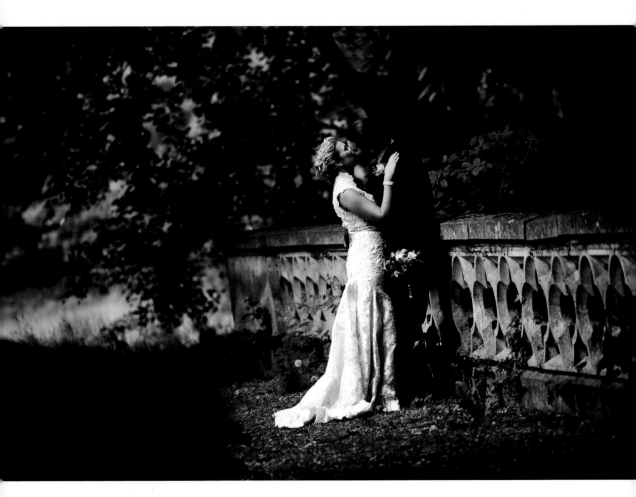

FIND GREAT LIGHT *(above)*

When I prepare to capture an image, I always try to find great light first. In this location at sunset, the sunlight shone in, and due to the way the trees grew, illuminated a small spot on the bridge. I had done my homework the day before and scouted out several locations at which to photograph on the day of the wedding. I wanted to be sure to make the most of the time I had with the couple.

When visiting a location for the first time, I try to get to the venue the day before the event so I can check out the area and find great locations. I strive to arrive at the same time at which I will be photographing my clients. The more prepared I am, the better the images will be.

Exposure: f/2.8, $^1/_{125}$ second, ISO 640. *Lens:* 70–200mm at 200mm.

"In this location, at sunset, the sunlight shone in, and, due to the way the trees grew, illuminated a small spot on the bridge."

TAKE A WALK AROUND (below)

As much as I say that you should plan ahead and scout locations if possible, sometimes weddings can throw you a curve and force you to think on the run. I like to just walk with the couple, when we have time, and wander around to see what cool places we can discover just around a corner. I try not wasting a lot of time, second-guessing whether I should take the images in my mind and forge them into existence; I just do it. I always assume that if I don't like certain images when I am culling, then I will just delete them.

Exposure: f/2.8, $\frac{1}{4000}$ second, ISO 200. *Camera:* Nikon D3. *Lens:* 17–35mm at 26mm.

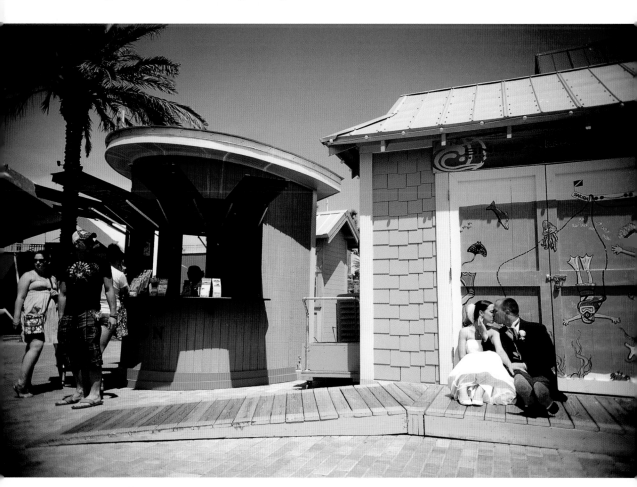

"I like to just walk with the couple, when we have time, and wander from place to place and see what cool places we can discover just around a corner."

SHOOT FOR THE CLIENT AND THE VENUE (below)

Remember how I said that when you are photographing a wedding, the couple is not your only client? When I made this image, I created it as much for the venue as I did for the couple. The Chateau de Challain, situated in the heart of the Loire Valley, always does such a beautiful job decorating for their clients, and in this case they had brought out this stunning vintage couch. I couldn't resist. I am not a big fan of the traditional images of a bride and groom standing in a nice pose in front of a pretty background, so I got the couple to lay all over this couch and just interact with each other, and voilà—magic!

Exposure: f/2.8, ¹/₃₂₀₀ second, ISO 400. *Camera:* Nikon D3. *Lens:* 14–24mm at 21mm.

VIVA LA DIFFÉRENCE (following page)

Being on your toes and mindful of your surroundings is vital to any wedding, not just destination weddings. I try to place myself with the most interesting parts of the venue as the background. The couple chose that destination and flew all that way so they could have a wedding that is completely different from every other wedding that their friends have, so you have to make sure that their images reflect that wow factor. The last thing you want is for your clients to go to a castle in the Loire Valley and come back with images that look like they got married at the local church.

Exposure: f/2.8, ¹/₆₄₀ second, ISO 400. *Lens:* 17–35mm at 35mm.

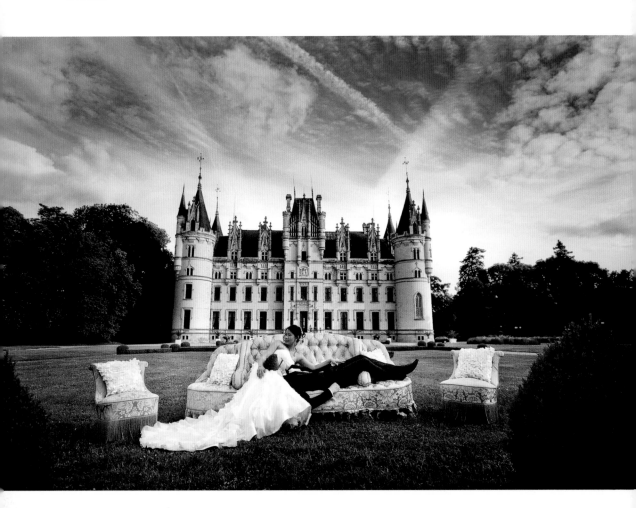

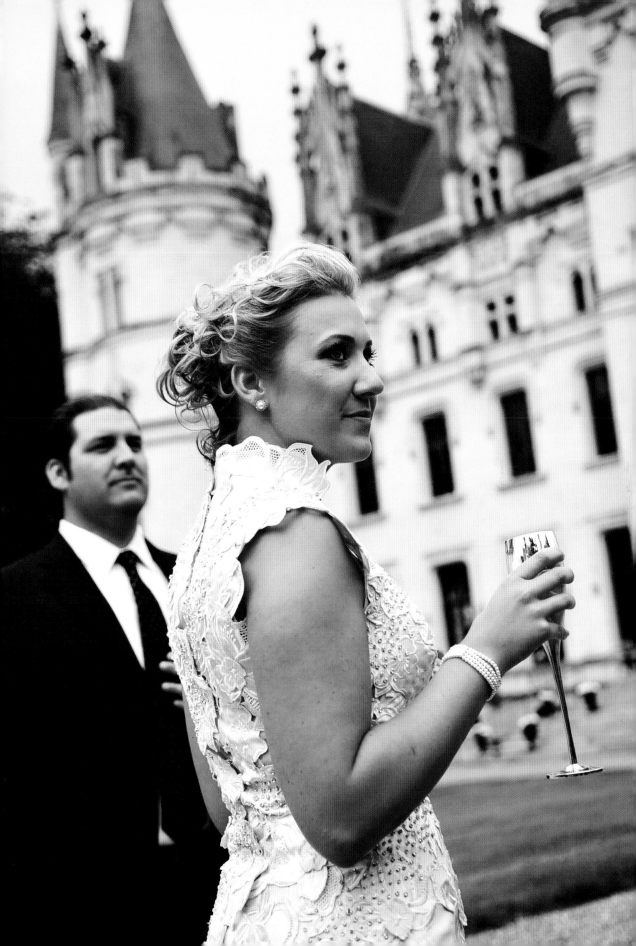

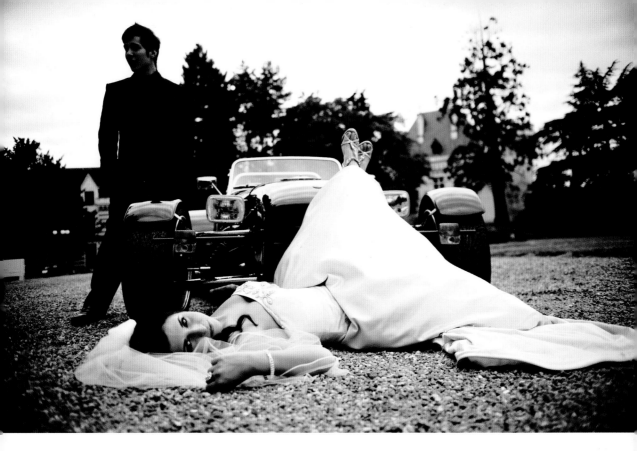

STAGE A DRAMATIC SHOT (above)

This is one of those photographs that might make people scratch their heads, but it's due to images like this that I have been flown all over the world to photograph weddings. Friends of the couple's family owned this beautiful car and let the couple borrow it on the day of the wedding, so I decided to make full use of it. I had intended to photograph just the bride lying in front of the car, but when the groom walked into the image, I immediately fell in love. I didn't want him to be the focus of the image, so I exposed for the bride and then, in post-processing, I burned the groom in so he would appear almost as a silhouette.

Destination: France. *Exposure:* f/2.8, $^1/_{1250}$ second, ISO 800. *Camera:* Nikon D3. *Lens:* 17–35mm at 32mm.

GREAT LIGHTING (following page)

After photographing this wedding at a courthouse in France, my clients and I were supposed to head over to the chateau for the reception. I thought it might be nice to get some images around the courthouse. I shot this image in the courtyard of a church that was nearby. It was a tad overcast, but the archways and high walls gave us enough give and take on the lighting ratios to create some beautiful portraits.

Destination: France. *Exposure:* f/2.8, $^1/_{1250}$ second, ISO 800. *Lens:* 70–200mm at 120mm.

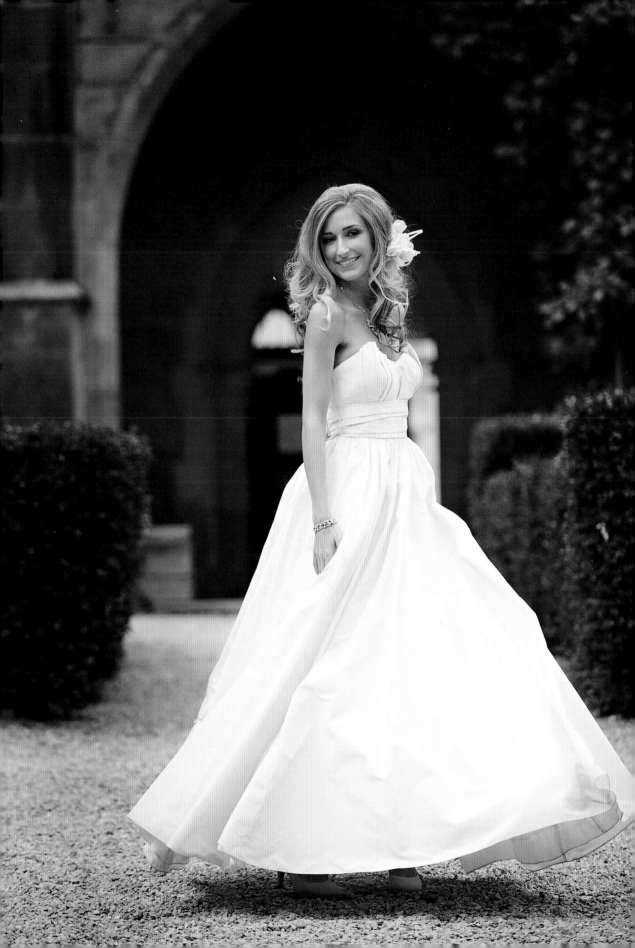

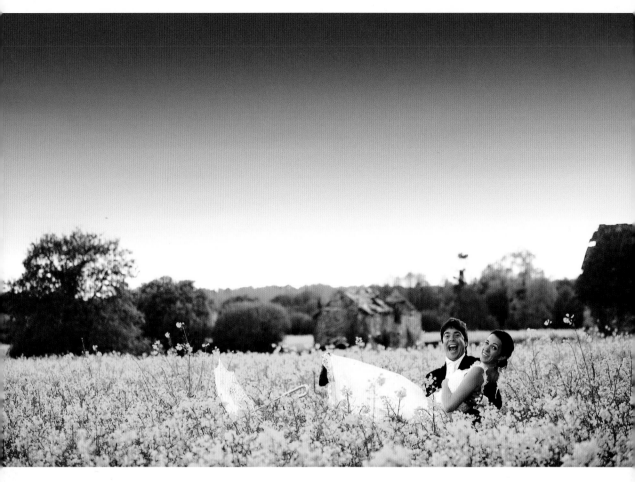

A FIELD OF FLOWERS (above)

AnaCarolina and Gabriel traveled all the way from Ven-ezuela to France to get married. One of the things they wanted to do was to have some photographs taken in one of the fields covered in flowers. After we had photographed around the venue and before the reception started, we had some extra time. Cynthia, the owner of the chateau, sug-gested a location that was not far from the venue, so we all hopped into the car and headed over. We traipsed into the field, which was messy, as it had just rained. Letting the couple just play together in the field of gorgeous blooms, I shot frame after frame.

Destination: France. *Exposure:* f/2.8, ¹/₆₄₀ second, ISO 800. *Lens:* 70–200mm at 70mm.

"Letting the couple just play together in the field, I shot frame after frame."

LANGUAGE BARRIER (below)

Outside the castle, on the set of the *Beauty and the Beast* musical, Mila was sitting in a chair. She looked incredible, so I motioned to have Vlad come over and get behind her. When you can't speak the language of the couple you are photographing, you become something of a mime! Instead of talking, you spend the majority of your day flailing your arms about wildly and end up finishing the day more exhausted than usual.

Exposure: f/2.8, $\frac{1}{40}$ second, ISO 250. *Exposure:* 70–200mm at 70mm.

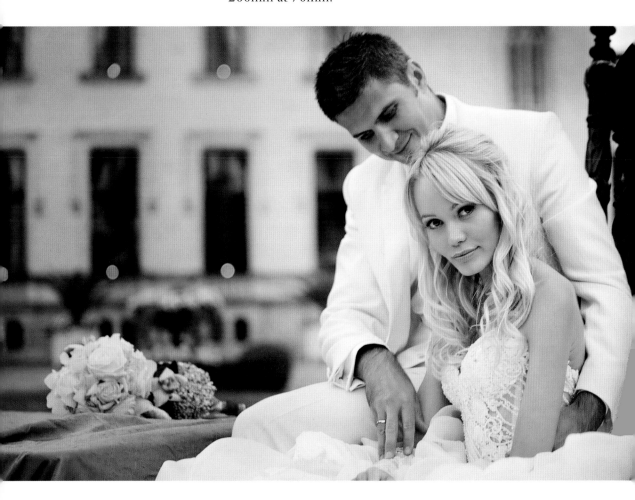

"When you can't speak the language of the couple you are photographing, you become something of a mime!"

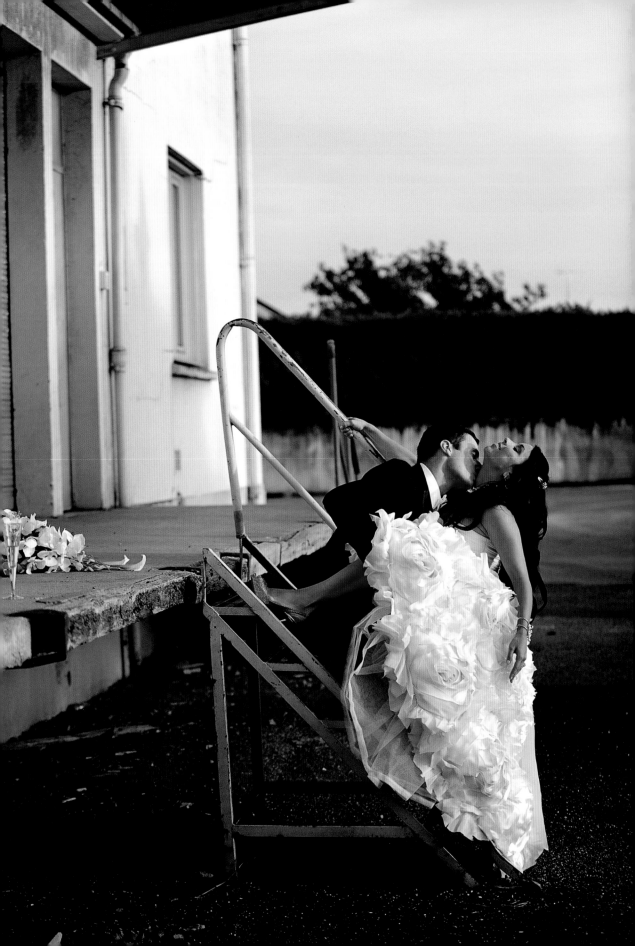

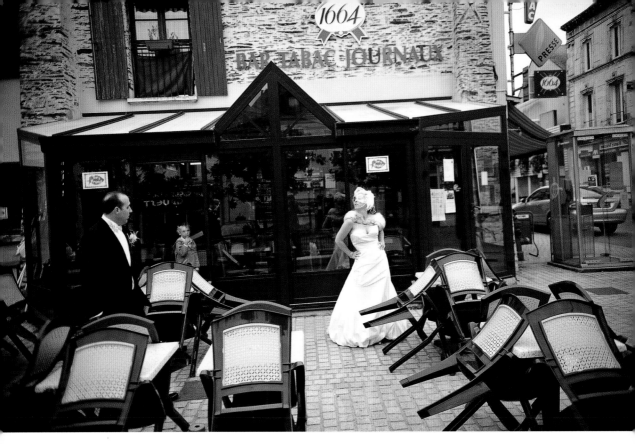

ALTERNATIVE LOCALES *(previous page)*

We don't just look for beautiful locations when creating images. For example, even though we were at a stunning castle in France in this case, we decided to take the bride and groom for a drive into the surrounding area to find other interesting settings. We came across this warehouse, which I could not resist using as a backdrop. Ludwig sat on the steps and Lindsey sat on his lap. I had her prop her leg up beside him to add drama to the image.

Destination: France. *Exposure:* f/2.8, $^1/_{1600}$ second, ISO 640. *Lens:* 70–200mm at 70mm.

SCHEDULE FOR SUCCESS *(above)*

I like to push to have as much time with the bride and groom as possible, so that I can get many images of them together. We keep in contact leading up to the wedding to try and help with the construction of the timeline. There is so much that can happen at a wedding that can interfere with the pictures, but if you allow yourself plenty of time with the couple, the impact of any interferences should be minimal.

I like to have the extra time so that after photographing at the venue, I can take the couple to surrounding areas to create some really cool images. I was able to do this with Brandi and her groom; we went into the nearby town and took images around the area. We could not have done this if we'd only had ten or fifteen minutes.

Exposure: f/2.8, $^1/_{250}$ second, ISO 1000. *Lens:* 17–55mm at 28mm.

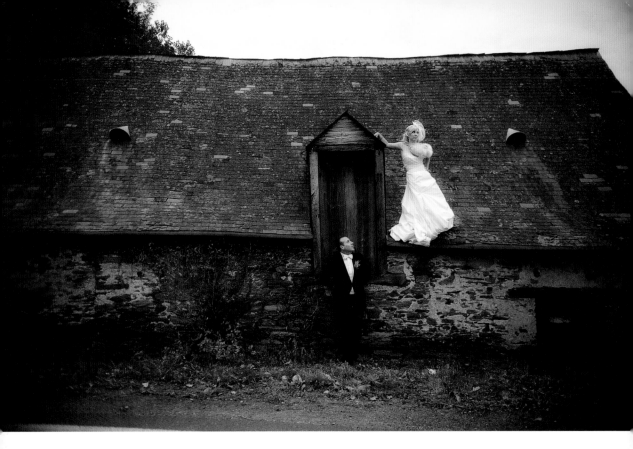

GO OUT ON A LIMB (above)

As we drove from town back to the chateau, we passed by this incredible old home. My philosophy is if you don't ask the couple if they are willing to try something special, it's as if you asked and they said "no."

This couple was game for a special shoot. I had the groom lift the bride up onto the roof and had him stay on the ground. I love this image, and I am glad that I took the chance to ask if the couple would agree to my taking this shot.

Exposure: f/2.8, $^1/_{200}$ second, ISO 1000. *Lens:* 17–55mm at 28mm.

A NATURAL VIGNETTE (following page)

I love to use what's around me to create visually stunning images. When Nathalie and Rodrigo took a walk around the chateau,

I followed them, taking images the whole way. I ran down into the creek so I could shoot with the chateau in the background. I used the tree to my right and the tree to the left of the couple to create a natural vignette. I wanted to throw the chateau out of focus, so I used a wide-open aperture and zoomed out far enough so as to not crop in too tightly on the chateau. I wanted to ensure that it was visible in the frame.

Exposure: f/2.8, $^1/_{160}$ second, ISO 400. *Lens:* 70–200mm at 155mm.

"I used the tree to my right and the tree to the left of the couple to create a natural vignette."

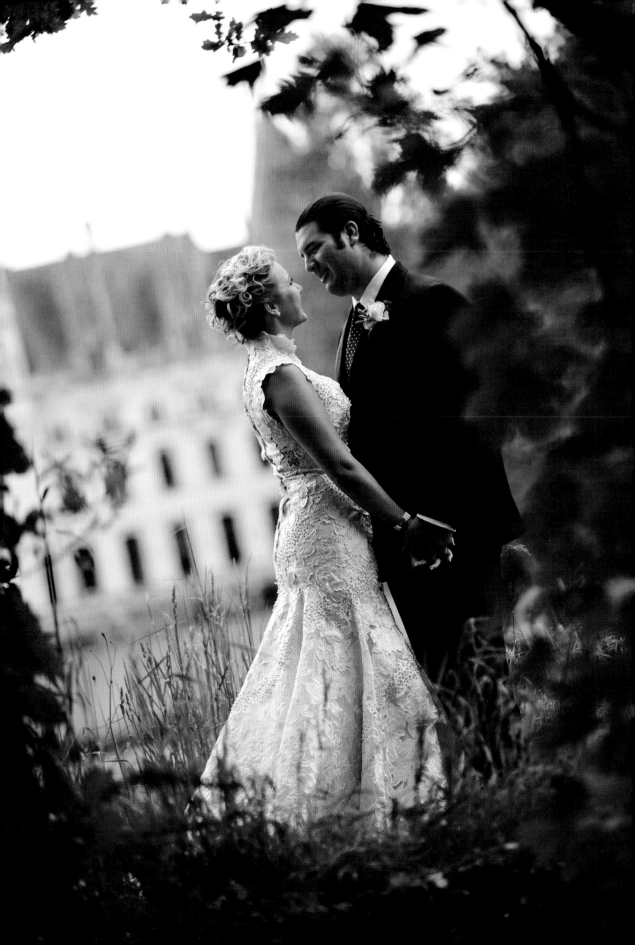

A DARING DUO (below)

It has always amazed me that my clients tend to go to extremes to make their images unique and extraordinary. For this image, I asked Nina to get in the window of the bedroom on the second floor of this castle, which was about 100 feet from the ground. Once she was in the window, her husband crawled out there and kissed her on the hand. No fancy lighting was used; I was simply ready to shoot at the right time, with a telephoto lens.

Exposure: f/2.8, $^1/_{320}$ second, ISO 320. *Camera:* Nikon D4. *Lens:* 70–200mm at 70mm.

PARIS, FRANCE (following page)

Who could resist a trip to see the Eiffel Tower when your clients' destination wedding is in Paris? Dodging tourists and the pesky photographers who swoop in on you like vultures can be tricky. We arrived at Le Trocadéro, which has a gorgeous view of the Eiffel Tower. I photographed in a few different places around that site before being harassed by the on-site photographer, who kept insisting that I get in the image with the couple so that he could take the picture. We evaded him by going all the way back to the wall, which is bookended on both sides by a long staircase that leads one down to the gardens below. In doing so, I was able to create this beautiful and romantic image of the couple with the Eiffel Tower in the background.

Destination: France. *Exposure:* f/4.0, $^1/_{1000}$ second, ISO 200. *Lens:* 70–200mm at 84mm.

"Who could resist a trip to see the Eiffel Tower when your clients' destination wedding is in Paris?"

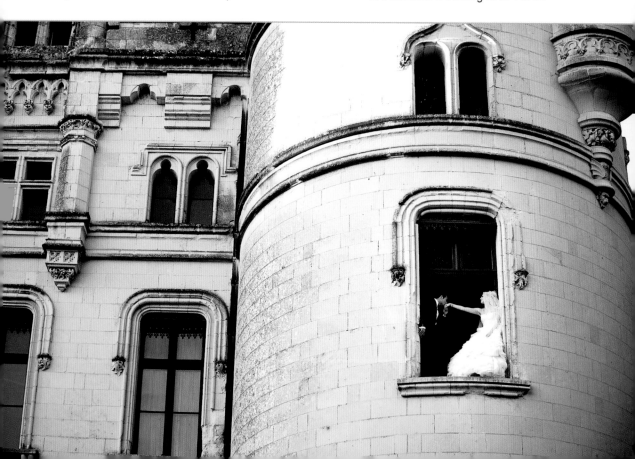

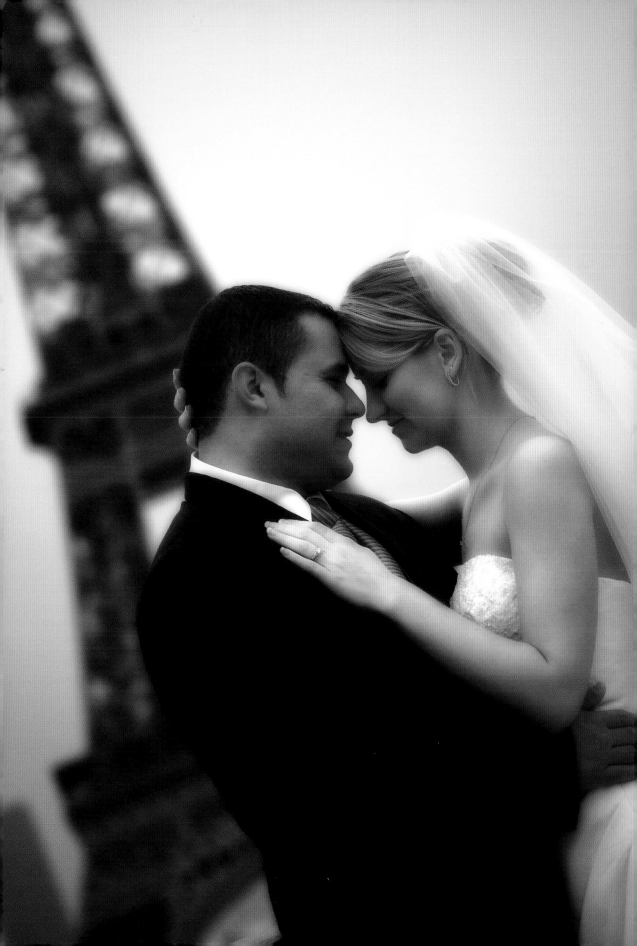

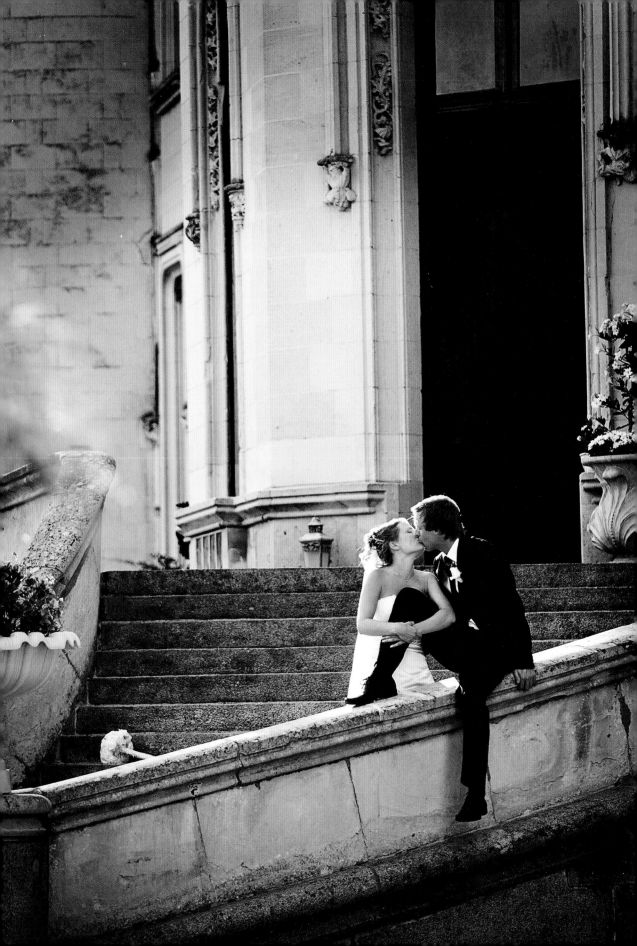

A SUNSET GLOW (*previous page*)

Kristin and Terje had their wedding in France at the Chateau de Challain in the Loire Valley. You can't go wrong in these situations; there are simply no bad backgrounds. I positioned the bride and groom on the steps leading up to the entrance of the chateau with the setting sun behind them. I wanted the light to give them a beautiful glow, and it worked perfectly.

Exposure: f/2.8, $\frac{1}{2000}$ second, ISO 400. *Lens:* 70–200mm at120mm.

COMMUNICATION (*right*)

In the atrium of the Mayfair Hotel and Spa in Coconut Grove, FL, there is a beautiful spiral staircase. Now the trick with photographing so far away is communication. Though you can yell at the couple across a beautiful venue, this is probably not the best option. You can tell them what to do ahead of time and then hope they pull it off. Or you can send someone with them, provided you have an assistant, and communicate through a cell phone. In this case, we went with option #2— however, option #3 is preferable!

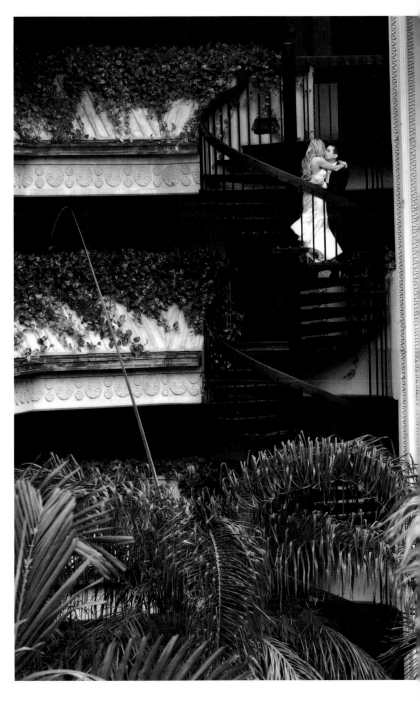

"Though you can yell at the couple across a beautiful venue, this is probably not the best option."

" . . . we spent hours driving all over Paris and photographing in all the top spots. We also made it to a few locations that were off the beaten path."

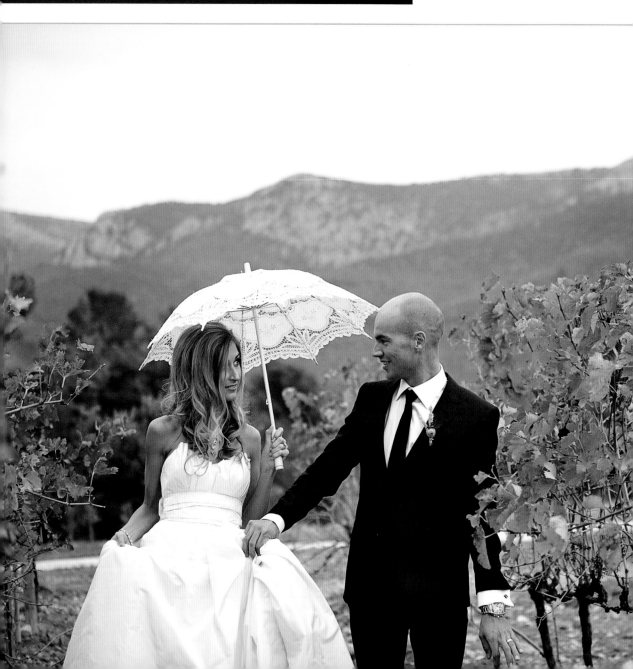

KEEP AN OPEN MIND *(previous page, top)*

Our first overseas wedding was in Paris, France. It was a very small but beautiful ceremony held in the gardens of the Louvre museum. After the ceremony was finished, we spent hours driving all over Paris and photographing in all the top spots. We also made it to a few locations that were off the beaten path. I always try to keep an open mind when it comes to location scouting so that I don't miss a great shot because I wasn't looking for it. The Louvre has beautiful hallways outside of the museum that overlook the grounds. I hadn't planned to photograph there, but when I saw the light and the possibilities, I couldn't resist.

Destination: France. *Exposure:* f/5.6, $^1\!/_{60}$ second, ISO 200. *Lens:* 70–200mm at 84mm.

MYRIAD OPTIONS *(previous page, bottom)*

Day-after sessions are one of the definite perks to destination weddings. You have so many beautiful locations at your disposal when you are traveling, and often, on the day of a wedding, there isn't enough time to capture all of the images you'd like to have of the bride and groom. With a day-after session, you can schedule two to four hours to run around and create gorgeous images without people getting in your way or stopping the couple to say hello.

Exposure: f/2.8, $^1\!/_{320}$ second, ISO 800. *Camera:* Nikon D3. *Lens:* 70–200mm at 70mm.

"With a day-after session, you can schedule two to four hours to run around and create gorgeous images without people getting in your way or stopping the couple to say hello."

SOMETHING OUT OF THE ORDINARY (below)

After the ceremony was over, Nina and Mark were whisked away in a horse and buggy for a tour of the grounds. I hopped onto an ATV and followed them around. I knew the layout of the venue because I scouted it ahead of time and decided that I was going to stop them on this bridge. I had Nina get up on the side of the bridge and sit with her legs dangling off the side. Mark was a different story. I could have placed him standing beside her, but that seemed overdone and ordinary, so instead, I had him get up on the side of the bridge and stand behind her. Then it was up to me to make the image more interesting by composing the shot to include the horse, buggy, and the driver in the frame.

Exposure: f/2.8, ¹/₅₀₀ second, ISO 400. *Camera:* Nikon D4. *Lens:* 70–200mm at 70mm.

DRIFTWOOD BEACH (following page, top)

When the ceremony was over, we decided to take Elizabeth and Chandler to Driftwood Beach. There are a number of fallen trees there that have been exposed to salt water, and it is one of the most romantic beaches in the world. We definitely got lucky, as there was a break in the rain, as what I would guess was the eye of the storm passed over us. We were presented with a few minutes without rain to take the couple's images. As it turned out, we also had the opportunity to take images with a rainbow behind them.

The longer we were at the beach, the worse the weather became. We worked quickly and didn't worry too much about the rain that had started to fall. It was a blessing that the bride and groom didn't care

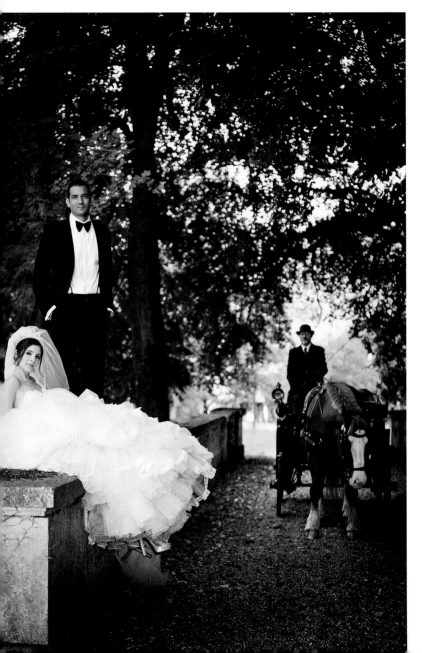

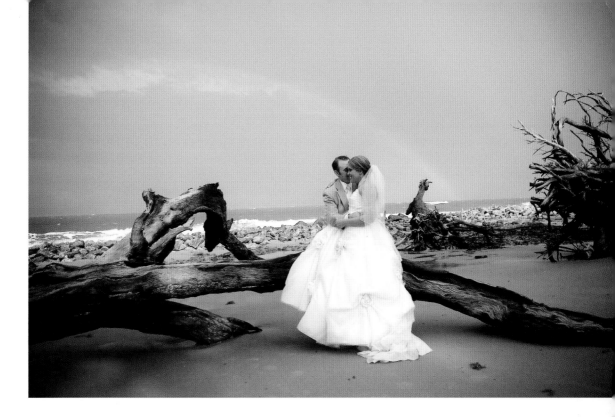

about getting wet; all they wanted was to have epic images from their wedding.

Exposure: f/2.8, $^1/_{1250}$ second, ISO 160. *Lens:* 70–200mm at 102mm.

AMAZING IMAGES (right)

With my camera wrapped in a towel so it wouldn't get wet, we continued to shoot. You can actually see the rain falling in this image. I was not under an umbrella or an overhang, I was right there with my clients.

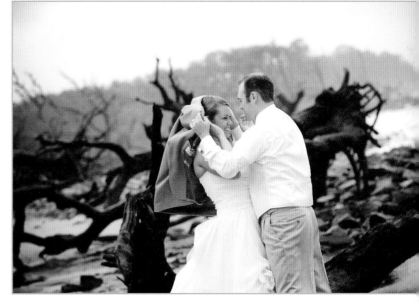

I am not shy about putting my equipment at risk if it means that I can get an epic photograph. Whether I am faced with a hurricane or standing in the middle of the Champs-Élysée dodging traffic, I have always felt like equipment can be replaced, but the image is forever!

Exposure: f/2.8, $^1/_{1250}$ second, ISO 160. *Lens:* 70–200mm at 102mm.

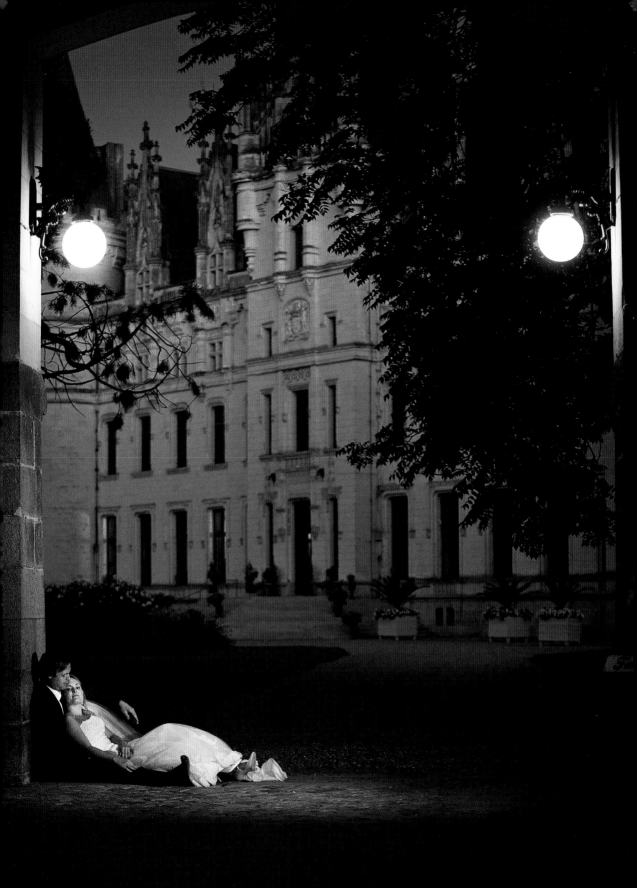

DRAMATIC NIGHTTIME IMAGES (previous page)

I love working at night! Those precious moments as the light leaves the sky make for such beautiful images. The couple had told me that they wanted an image where you could see the castle in the background and that they also wanted it to have that signature blue that we capture in so many of our nighttime images. I positioned them directly under the lamp that was on the gate so that it would cast its light down on the couple, then I added a touch of light from a video light that I had off to camera right. I set the white balance to tungsten to draw out the blue from what was left of the available light at this time of night.

Exposure: f/2.8, $\frac{1}{60}$ second, ISO 2000. *Lens:* 70–200mm at 78mm.

AN ALTERNATE VIEW (right)

After we left the gate, I looked behind me and saw that we could get the same effect under the streetlights in this tiny French town. For this image, I placed the video light behind the couple to give the image a more dramatic feel. In these images, I had the ISO pumped up to 2000, and the shutter speed was set to $\frac{1}{60}$ second to maximize the amount of light that I would be able to bring into the image.

Exposure: f/2.8, $\frac{1}{60}$ second, ISO 2000. *Lens:* 70–200mm at 95mm.

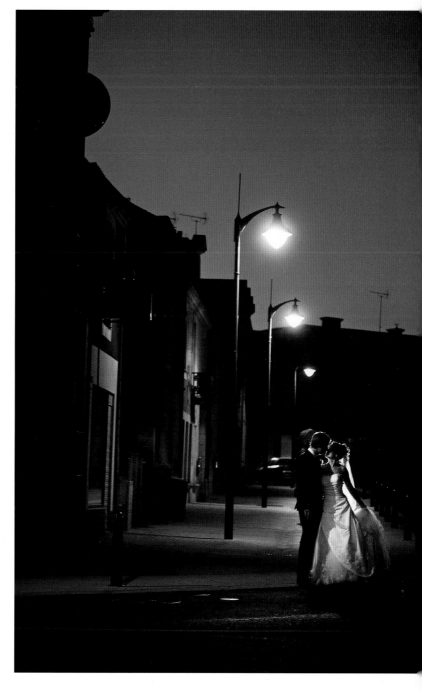

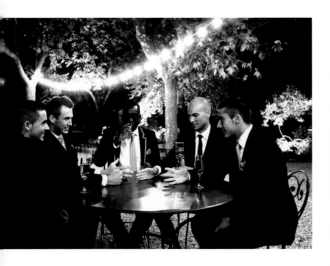

RECEPTION DOWNTIME *(above)*

Some parts of the reception are a bit slower than others. I take the opportunity to create cool imagery during these downtimes. As the night drew on, I recognized one of those very moments and asked the grooms-men to step outside. Using only the available light coming from the overhead string lights, I increased my ISO to 4000 and shot away.

Exposure: f/2.8, ¹/₃₀ second, ISO 4000. *Camera:* Nikon D3. *Lens:* 17–35mm at 35mm.

STARRY NIGHTS *(right)*

When given the opportunity and the right conditions, I love shooting images at night with the stars showing in the sky. In Germany, near Stuttgart, there is a hunting lodge that also has some ruins. Early on in the day, I had selected the locale for some late-night fun. Once it was dark enough, I enlisted some help, as Dawn was home with our two-year-old son, and off we went. I set up my tripod and took some test shots to make sure I had the exposure correct. I started the timer for the shutter release to avoid camera shake. When the shutter opened, I lit the couple briefly with a video light. I had the white balance set to tungsten to balance with the video light and bring out the blue in the sky.

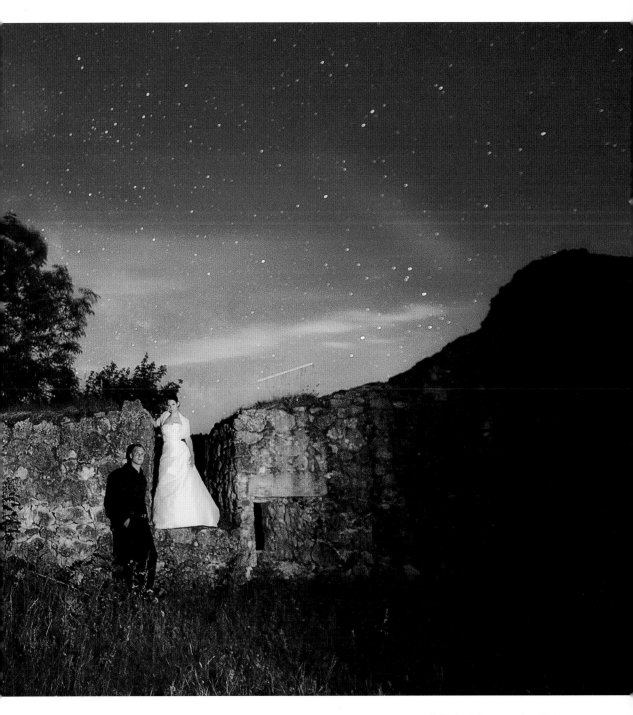

Destination: Germany. *Exposure:* f/2.8, 30 seconds, ISO 2500. *Lens:* 14–24mm at 17mm.

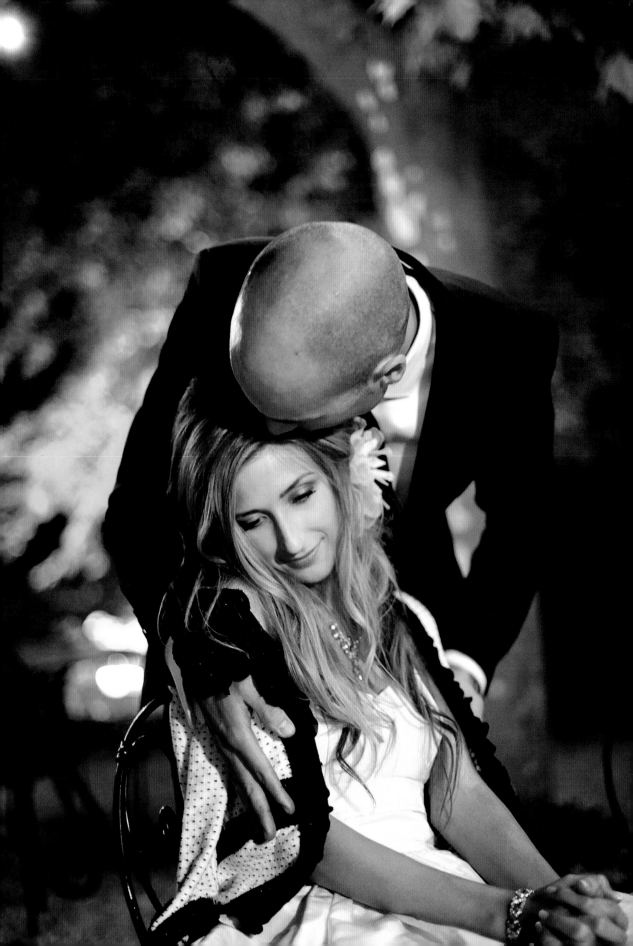

KEEP IT NATURAL

(previous page)

Letting the time together for a couple flow naturally has been the best way for me to capture beautiful intimate portraits that reflect their personality better than anything that I can pose. I try and set the place and the mood and let the couple's interaction direct the pace and the posing. This sweet moment was brought on by a chilly night in October in southern France.

Exposure: f/1.4, $^1/_{80}$ second, ISO 4000. *Camera:* Nikon D3. *Lens:* 50mm.

RECRUITS *(right)*

Receptions can be tricky to shoot, especially when you are working without assistants. So what do you do? Recruit! I convinced some of the staff to help me by holding flashlights. Why flashlights? They don't take up much room in the camera bag and they are easy to use! One can also get some very interesting lighting from them. It's hard to take a lot of gear when you travel overseas.

Exposure: f/2.8, $^1/_{25}$ second, ISO 4000. *Lens:* 14–24mm at 24mm.

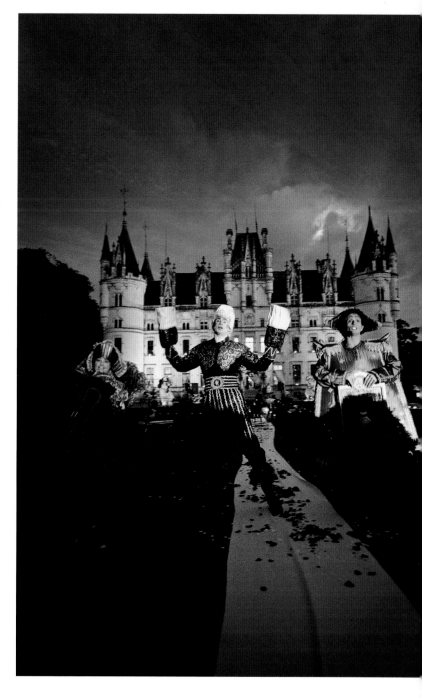

"Why flashlights? They don't take up much room in the camera bag and they are easy to use!"

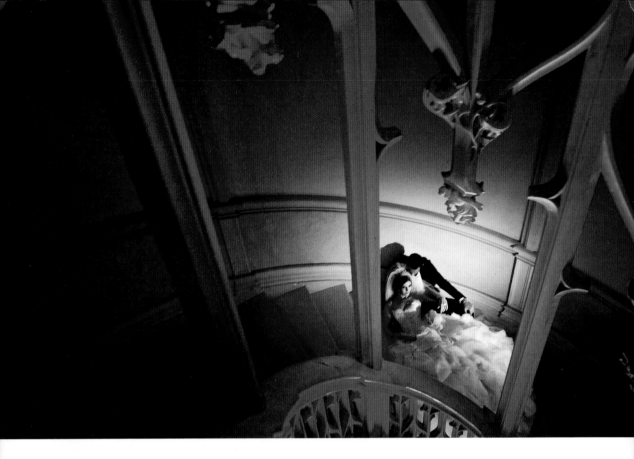

8 ARTFUL INTERIORS

HELP FROM VENDORS *(above)*

Always being aware of what you can borrow from other vendors comes in handy! I spaced out at this wedding and forgot to use my converter when I plugged in my video light battery, and so I blew the battery. Now, my video light wasn't going to work and I really wanted some creative shots with the up-lighting in this beautiful staircase. I noticed the videographer had a video light that was in his bag, so when we got to the stairs, I asked to borrow it. The videographer held the light for me, and I shot through the structure of the stairs to draw attention to the couple.

Exposure: f/2.8, $^1/_{30}$ second, ISO 1250. *Lens:* 14–24mm at 24mm.

A UNIQUE ANGLE *(following page)*

I wanted a different angle on the previous shot so I did the only thing I knew to do when you are trying to be as fast as you can—I jumped over the couple, without crashing down the stairs. I repositioned the pair and shot away, still letting the videographer hold the light for me. Dawn wasn't able to make this trip with me, she was home with our son.

Exposure: f/2.8, $^1/_{30}$ second, ISO 1250. *Lens:* 14–24mm at 24mm.

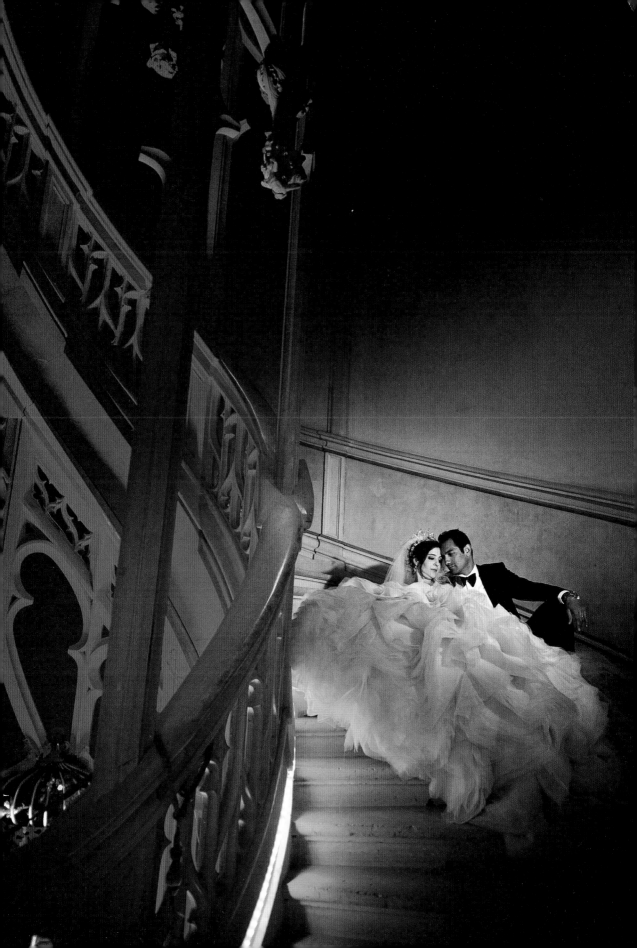

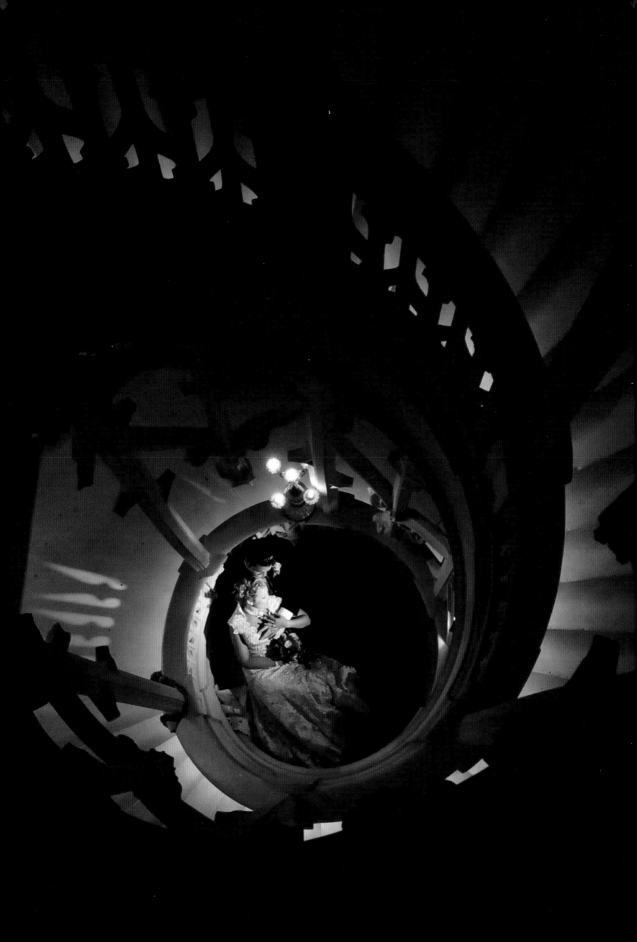

MIXED LIGHTING

(previous page)

There is a spiral staircase inside the Chateau de Challain in France that is just breathtaking. The idea was raised that we should photograph the couple inside the spiral of the staircase, and it sounded phenomenal. We used the light from candles and a Lowel ID video light to illuminate the couple. The inner part of the stairs was lit by string lights.

Exposure: f/2.8, ¹/₄₀ second, ISO 2000. *Lens:* 17–55mm at 19mm.

A FRESH APPROACH *(right)*

I photographed Lindsey on the servant's staircase in a gorgeous chateau in France. I had been to this venue many times and I wanted to do something different than what I had done at my other weddings. I had scoured the location looking for a spot that jumped out at me when it hit me. I use this staircase all the time and I just hadn't seen the potential for it. I positioned her on the staircase and had her turn her head toward the light that was on the wall just behind the door frame to properly illuminate her face.

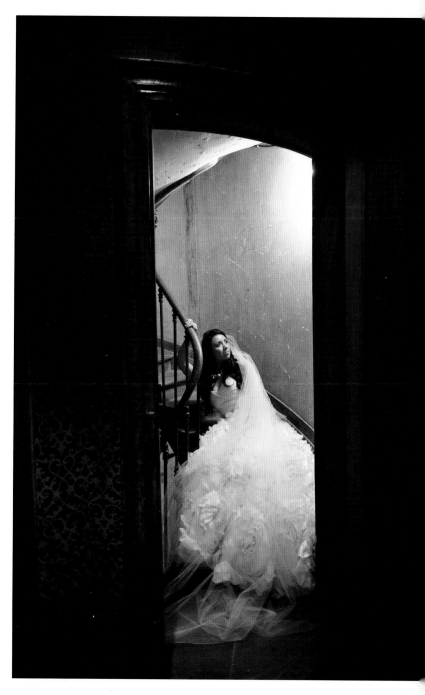

Exposure: f/2.8, ¹/₄₀ second, ISO 2000. *Lens:* 17–55mm at 23mm.

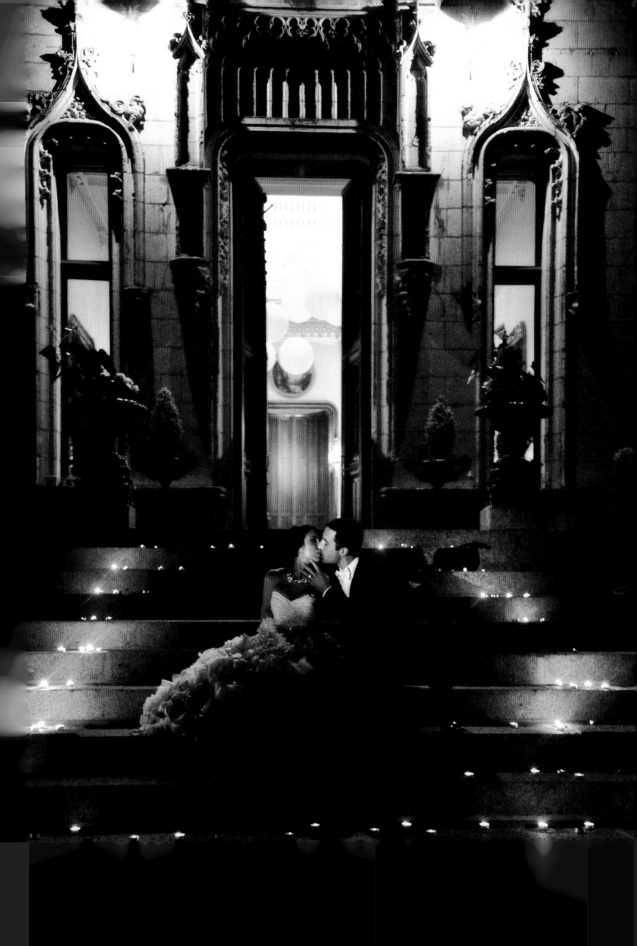

ROMANTIC LIGHTING (*previous page*)

While the reception was underway, I asked a few friends who worked at the chateau to help me by lighting candles. By the way, candles are easy to keep lit when it's breezy out. When all the candles were lit, I brought out the couple and got them into position, making sure to not catch the bride's dress on fire. I didn't want an overwhelming amount of light, so to light the couple's faces, I used an LED flashlight. I used a slow shutter speed to draw as much light from the candles as possible.

Exposure: f/2.8, $^1/_{25}$ second, ISO 6400. *Lens:* 17–55mm at 31mm.

A BLUE HUE (*below*)

This is one of my favorite images. We had to time this shot to the minute. So often at weddings, we are at the mercy of the weather. If it's clear, you have a small window when you can get a shot like this. This shot was created just after sunset and before total dark so we could get that beautiful blue hue in the image. I had the bride pose against the lamppost while Dawn held a Lowel ID video light on camera right to fill in the shadows the lamp created on the bride's face. I had the white balance set to tungsten to bring out the blue from the available light and balance the light from the lamp and video light.

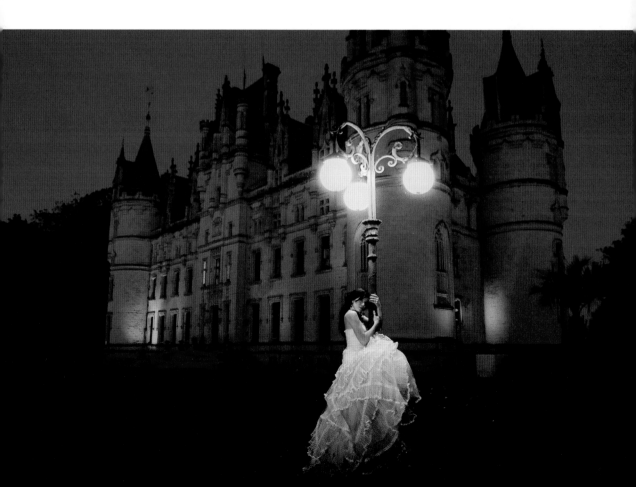

LEADING LINES (below)

Kanwal and Sohel celebrated the first two days of their wedding in Atlanta, GA, but then we all made the trip to Destin, FL, for the last day of their wedding where they would hold a ceremony on the beach and a reception at a beach resort. In between the ceremony and the reception, we had some time to do some bride and groom portraits at the resort. The problem we had was that it was dark, so we had to be creative with the location. We did some scouting around and found this section where two hallways met each other. We used a Lowel ID video light to light the couple from one hallway. Then I stood at the end of the other hallway so I could use the can lights as a leading line along with the lines from the hallway to draw attention to the couple.

Exposure: f/2.8, $^1/_{100}$ second, ISO 2000. *Lens:* 70–200mm at 70mm.

LED FLASHLIGHTS (following page)

This venue had a breathtaking staircase. We brought over a chair for the bride to climb up on so she could stand on the handrail. Once she was in place, I took a look at the overall staircase. I wanted to bring out the lighting that was on the stairs, so I set the ISO to 2500 and my shutter at $^1/_{40}$ second. Dawn lit the subject with two LED flashlights to restrict the light to the bride's face, rather than allowing it to spill across her dress. By the way, those two flashlights cost a total of about $10. You just have to love that!

Exposure: f/2.8, $^1/_{40}$ second, ISO 2500. *Lens:* 17–55mm at 38mm.

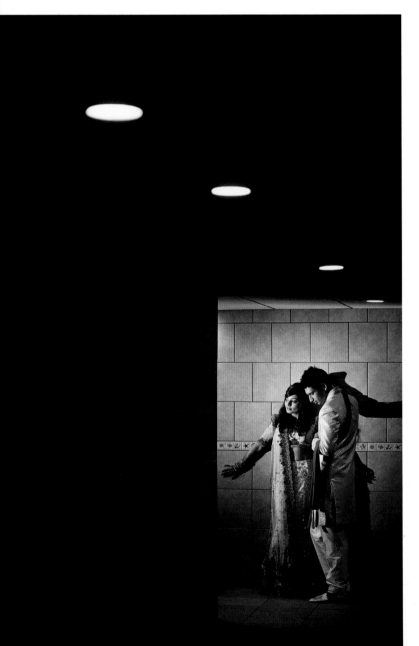

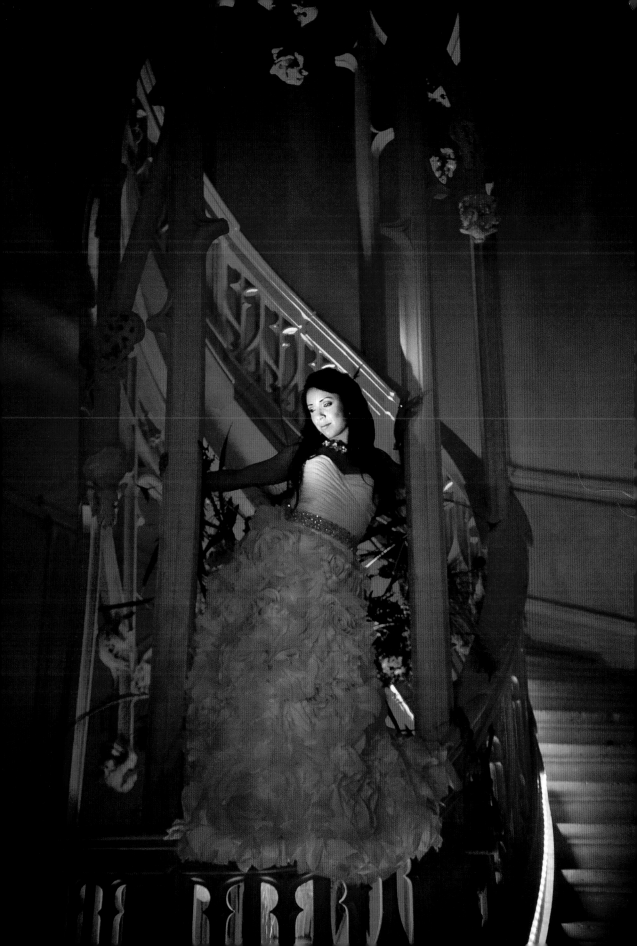

THE LAMP SERIES (below)

Don't be afraid to be different; don't let doubt hold you back. I felt so bad for Ginger, she had gotten very sick during the reception—she wasn't used to French food and I don't think it agreed with he. Still, she came back downstairs from her room to do portraits. I moved as fast as I could through the portraits, knowing that we were going to do a day-after session. I got this crazy idea in my head to get the couple to hold these lamps while we took the portraits. This is just one of the images in a personal project that I call *The Lamp Series*. I love the way this portrait turned out.

Exposure: f/2.8, ¹/₈₀ second, ISO 1600. *Camera:* Nikon D3. *Lens:* 17–35mm at 19mm.

"Don't be afraid
to be different; don't let
doubt hold you back."

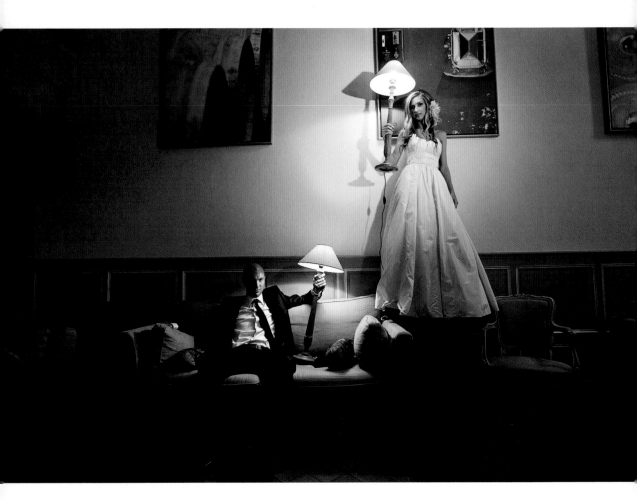

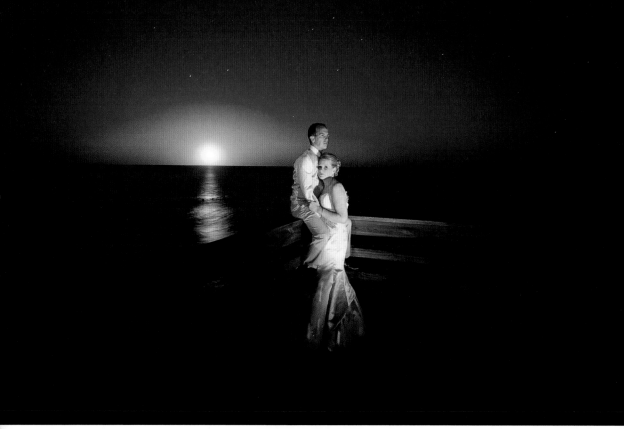

BY THE LIGHT OF THE MOON (*above*)

During the reception, I noticed that the moon was setting over the ocean just outside of Charleston, SC. It was a beautiful night, and there was a break in the action of the reception that gave us the window we needed to create something awesome. It was pitch black outside except for the light from the moon. We positioned the couple on the dock, instructing them to stand as still as possible. Kristen, Dawn's sister, took our Lowel ID video light down the stairs on camera right so she would stay out of the frame. With my camera on a tripod, I set the timer for 30 seconds and pressed the shutter. Kristen turned the light on and quickly off so that the camera would record the illumination on the couple.

Exposure: f/2.8, 30 seconds, ISO 640. *Lens:* 14–24mm at 18mm.

"Kristen turned the light on and quickly off so that the camera would record the illumination on the couple."

AFTER THE WEDDING

A SENSE OF ADVENTURE

(previous page and right)

Dawn and I have traveled to some very cool places to photograph weddings. One of the perks of destination wedding photography is the ability, if time permits, to accompany the couple on some of their honeymoon activities. We offer this option to our clients, and while not every couple takes us up on it, we do sell the add-on from time to time. From the mountains of Costa Rica to the streets of Pamplona, Spain, it's been a wild ride.

Exposure: f/2.8, $^1/_{320}$ second, ISO 160. *Lens:* 17–55mm at 52mm.

"One of the perks of destination wedding photography is the ability, if time permits, to accompany the couple on some of their honeymoon activities."

THE MORNING AFTER (*below*)

Waking up the day after a wedding can be hard, but making the effort can be very beneficial. Scheduling an extra day so we could get more time with the couple was so important. We were able to capture beautiful images of the bride and groom (shown on the next several pages), but I really wanted to be able to get the feel of the day after the wedding in the images. I shot this image inside the couple's hotel room without having cleaned up. Around the room were empty clothing bags and champagne bottles, which I felt added to the images as a whole. In my opinion, it's not always necessary to hide all the evidence of life having happened.

Exposure: f/2.8, ¹⁄₅₀ second, ISO 1600. *Lens:* 17–55mm at 45mm.

"In my opinion, it's not always necessary to hide all the evidence of life having happened."

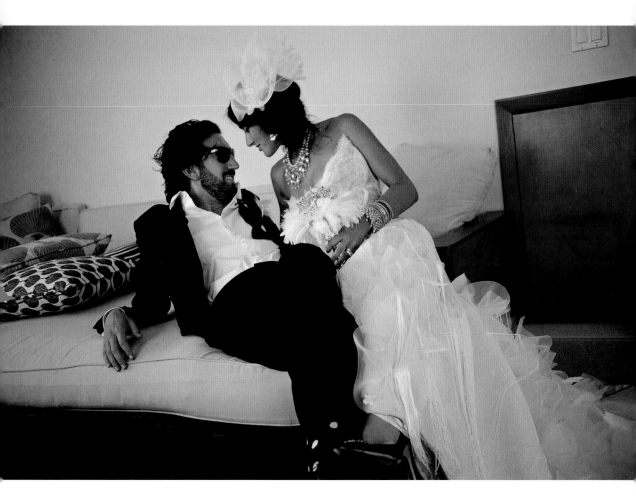

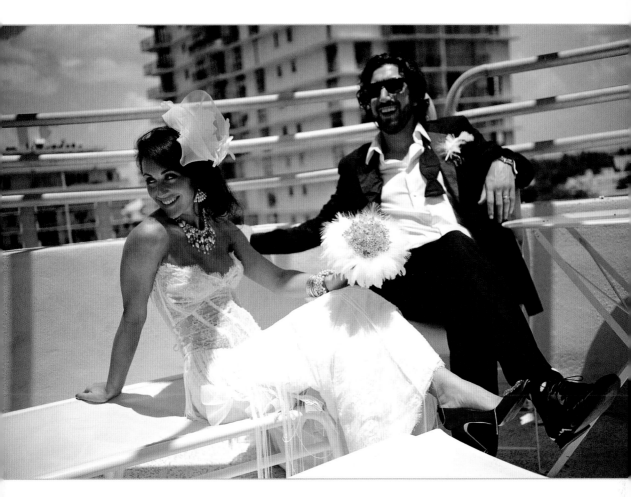

IMMERSE YOURSELF (above)

Get wrapped up in the couple's world if you can. When Ashley and Josh were married in Miami, FL, we were able to get a glimpse into their lives. For the entire weekend, we traipsed around South Beach doing everything that the couple does on a normal day. We traveled by cabs and went to the same clubs they do—and we had a great time doing it. It didn't leave us much time to take bride and groom portraits though. Since we were going to be there, we scheduled a day-after session with the couple so we could all have a more relaxed portrait session. We took this image on the balcony of the couple's hotel room. The result is a portrait that is just nice and relaxed.

Exposure: f/2.8, ${}^1/_{8000}$ second, ISO 320. *Camera:* Nikon D3. *Lens:* 17–55mm at 45mm.

"We traveled by cabs and went to the same clubs they do–and we had a great time doing it."

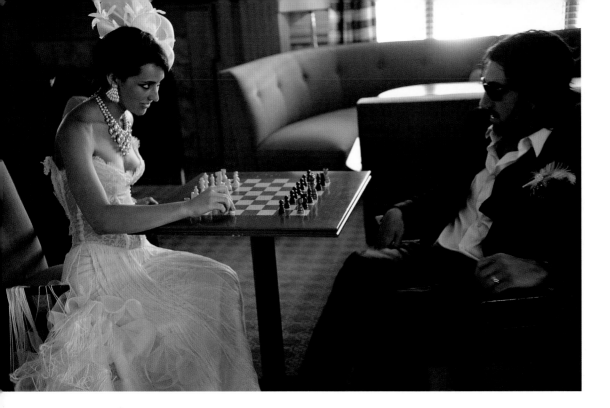

STRATEGIC MANEUVERS (above)

Once we headed downstairs to the lobby of Ashley and Josh's South Beach hotel, we came across this chess table. I wanted to get a very relaxed image of the couple, so I had them sit down at the table and begin to play chess. I had my ISO dialed up to 1600 to bring in as much available light as I could. I didn't want to bring out flashes or any additional lighting because I was worried that it might ruin the mood of the image. In situations like this when you are capturing candid moments, your couple won't always look their best, so you may have to step in and help a bit. We were very lucky, Ashley and Josh are the kind of couple who, even if they were pumping gas, would look fantastic in an image.

Exposure: f/2.8, ¹/₅₀ second, ISO 1600. *Lens:* 17–55mm at 45mm.

A PERSONAL TOUCH (following page)

If possible, include in the couple's images items that reflect their personality. During day-after sessions, you will often have more of a chance to do this because you do not have the stress of the wedding day surrounding your bride and groom. Cycling is a huge part of this couple's lives and their daily routines, so Ashley and Josh brought their bikes with them so we could take some images that showed their shared passion. The sun was pretty high at this point of the day, so I positioned the couple under some trees and Dawn bounced light back on them with a reflector.

Exposure: f/2.8, ¹/₄₀₀ second, ISO 320. *Lens:* 17–55mm at 32mm.

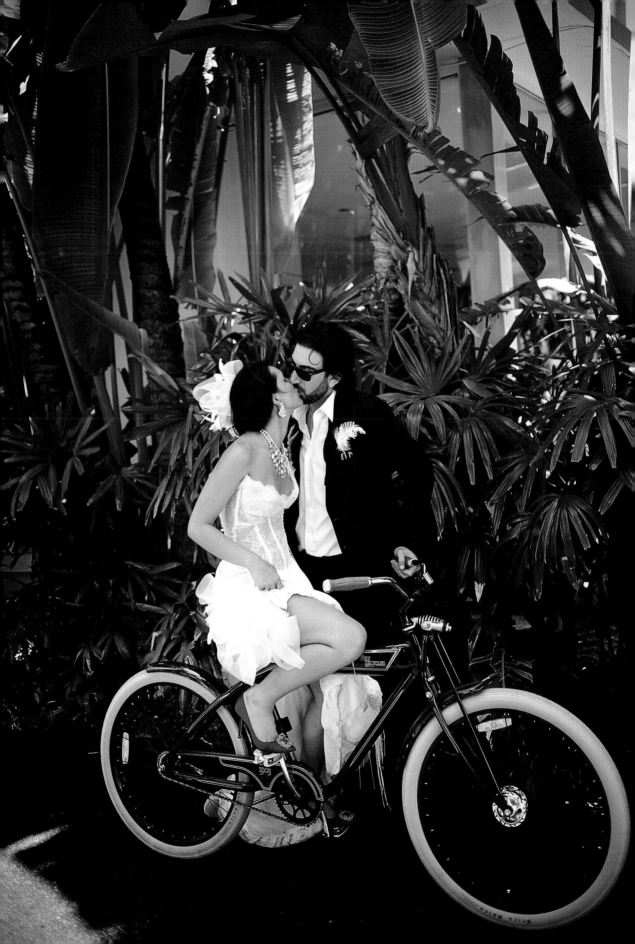

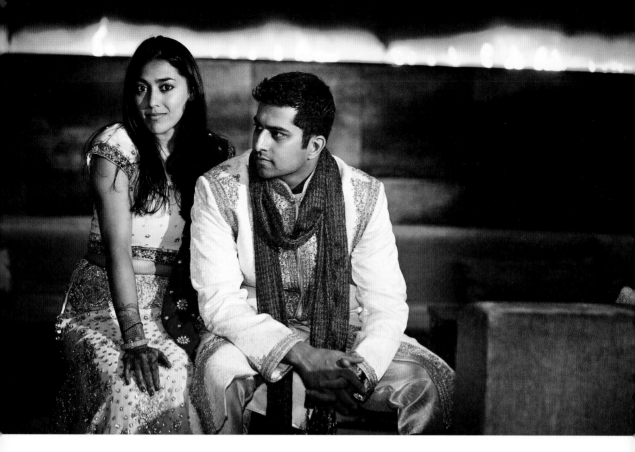

PROPER LIGHTING (above)

Inside the MGM Grand in Detroit, MI, there is a beautiful lobby with a fireplace along the wall. For this image, I had Aarti and Mehul sit down on an ottoman. Dawn used a handheld Lowel ID video light to add light on them. When using the video light (or any other kind of lighting), I try to obtain proper lighting. Dawn held the light at about a 45-degree angle to the couple, so it would give them a nice modeling effect on their faces.

Destination: Detroit. *Exposure:* f/2.8, $\frac{1}{15}$ second, ISO 400. *Lens:* 70–200mm at 82mm.

THE BRIDE FIRST (following page)

Right across the MGM Grand in Detroit, there is a parking lot that has a cool wall with different openings and vines running up and down across the structure. After walking across the street to get there, I started by working with the bride first. I like to place the bride in a great location and then take some shots of her just being herself. I was in love with the lighting in this location, and the square opening brings the viewer's attention to the bride. Later, I couldn't resist bringing Mehul over for some images of the bride and groom together.

Exposure: f/2.8, $\frac{1}{640}$ second, ISO 200. *Lens:* 70–200mm at 110mm.

> "I like to place the bride in a great location and then take some shots of her just being herself."

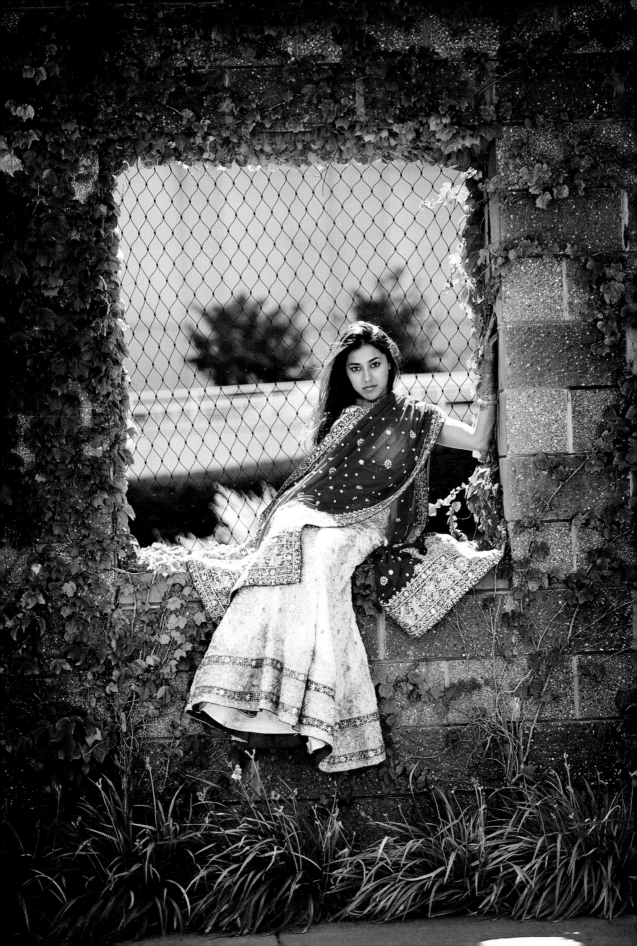

JUST ADD THE GROOM (below)

Once we added Mehul to this fantastic storm of goodness, I could shoot until my heart was content. I didn't want to move Aarti too much from the previous pose, so Mehul leaned back against the wall in front

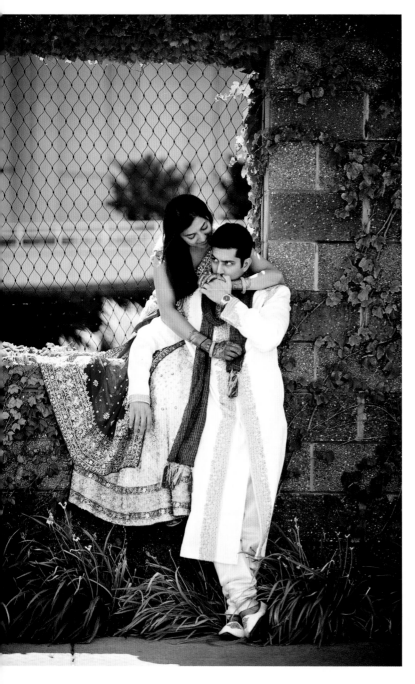

of her. In this case, I usually tell my clients to do what comes naturally. This doesn't always get the results I am looking for, but it can get me close, and I can guide them the rest of the way. Aarti and Mehul didn't need the extra prodding though. They looked great just being themselves.

Exposure: f/2.8, $^{1}/_{800}$ second, ISO 200. *Lens:* 70–200mm at 120mm.

EXPAND YOUR BOUNDARIES (following page)

Knowing that we would have some time to go from location to location, we did a little research and found some places that we thought would help make for interesting images. One of the sites was the Michigan Central Station, a train station that has sat unused since 1988. I would have loved to shoot inside, but the building is surrounded by barbed wire, so we stayed outside. After all, taking the couple's mugshots for breaking and entering wasn't a part of our master plan.

When traveling, always do your research and find cool locations. You can never count on coming back to these places again.

Exposure: f/2.8, $^{1}/_{3200}$ second, ISO 250. *Lens:* 70–200mm at 70mm.

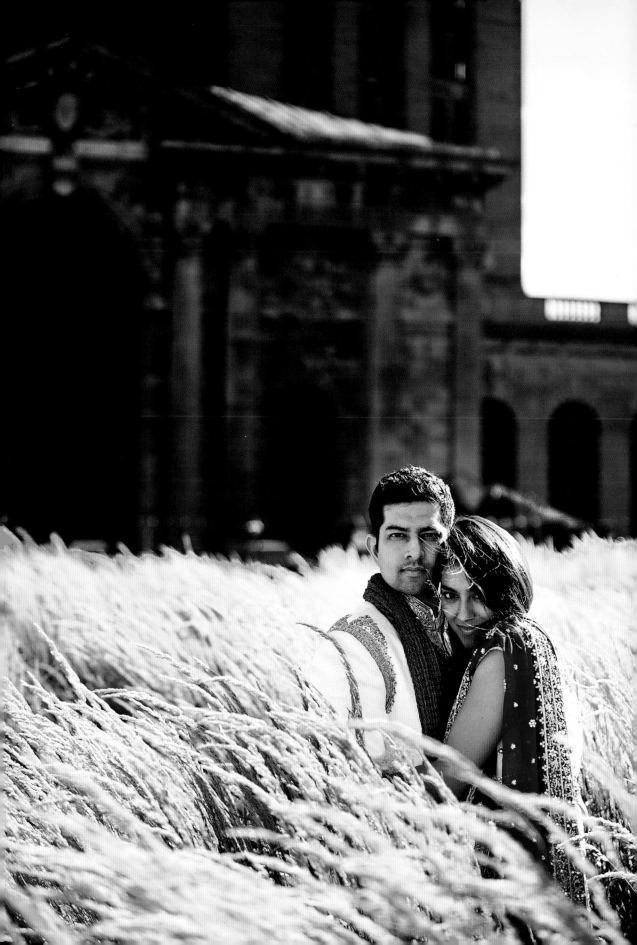

GREAT SPORTS *(below)*

While we were in Costa Rica for this couple's wedding, the bride and groom hired us to come with them on some of their honeymoon activities. (Not all of their activities, mind you—just some of them.) Dawn and I got to ride on ATVs and were also able to go zip-lining while we photographed all the fun.

Exposure: f/2.8, $^1/_{6000}$ second, ISO 250. *Lens:* 17–55mm at 38mm.

AN INTIMATE SESSION *(following page)*

After the ceremony was over, we were all by ourselves since we were the only ones who were there for the wedding. Naturally, we decided to take some bride and groom portraits around the resort. Even when we are in a gorgeous locale, I will create images that get in tight on the couple as well as those that show off the beauty of the area. You have to vary your poses and mix it up to provide maximum coverage for your clients.

Exposure: f/2.8, $^1/_{640}$ second, ISO 400. *Lens:* 70–200mm at 180mm.

"Dawn and I got to ride on ATVs and were also able to go zip-lining while we photographed all the fun."

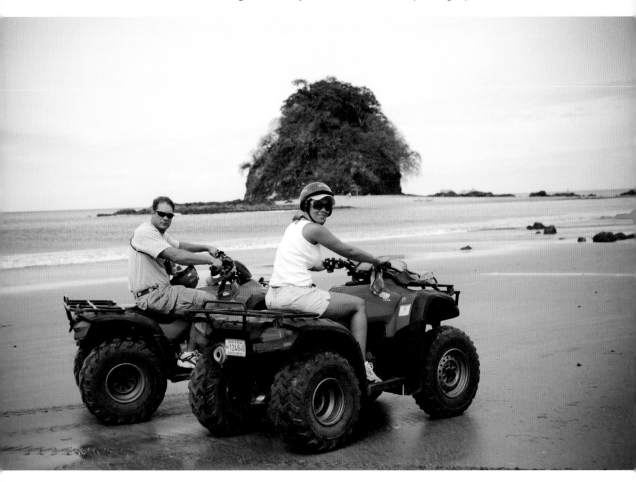

"Even when we are in a gorgeous locale, I will create images that get in tight on the couple, as well as those that show off the beauty of the area."

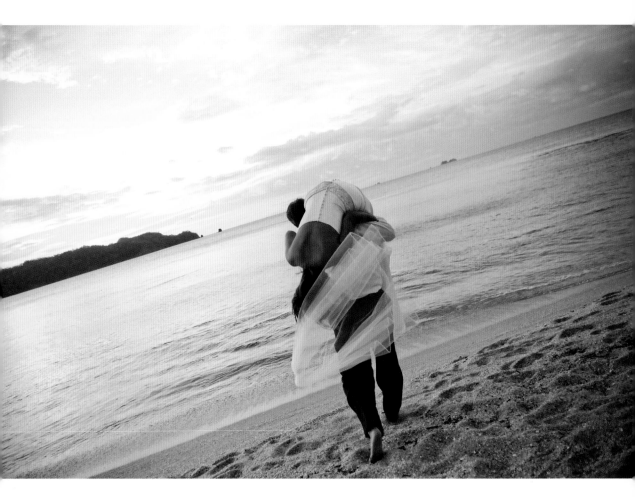

FUN-LOVING SHOTS (*above*)

After photographing all over the grounds of the resort, we arrived at the beach and we were ready to just have fun with the couple. I positioned myself and told the bride and groom to just have fun and play. The groom picked up the bride and hauled her into the ocean. It made for a great image!

Exposure: f/2.8, ¹/₈₀₀ second, ISO 400. *Lens:* 17–55mm at 25mm.

"I positioned myself and told the bride and groom to just have fun and play. The groom picked up the bride and hauled her into the ocean."

SELL THE SIZZLE (below)

Deciding to turn up the heat a bit more, Jeri unzipped her dress and leaned into Jay's chest. To ensure a successful image, I made sure that the couple's faces were illuminated by the setting sun. I had them positioned with their faces turned toward me, with the ocean behind them. This was one of my favorite images from their wedding. I love when couples will do anything to get the best-possible images, and Jeri and Jay were up for anything. Not all clients will be willing; sometimes, I have to encourage them with a little prodding and remind them that they will appreciate the effort later.

Exposure: f/2.8, $\frac{1}{160}$ second, ISO 400. *Lens:* 17–55mm at 48mm.

"Deciding to turn up the heat a bit more, Jeri unzipped her dress and leaned into Jay's chest."

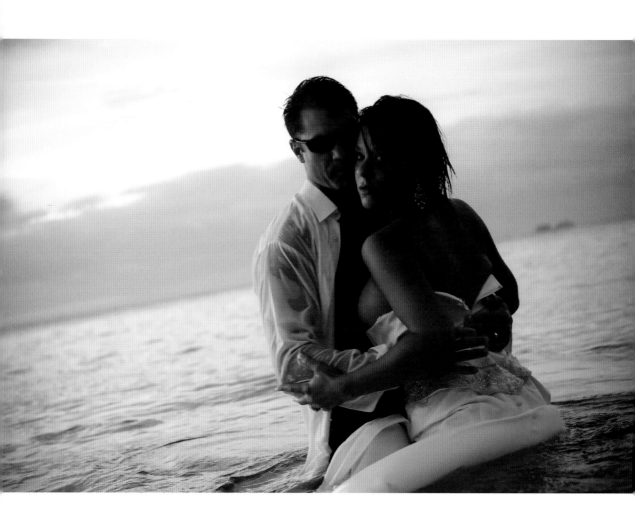

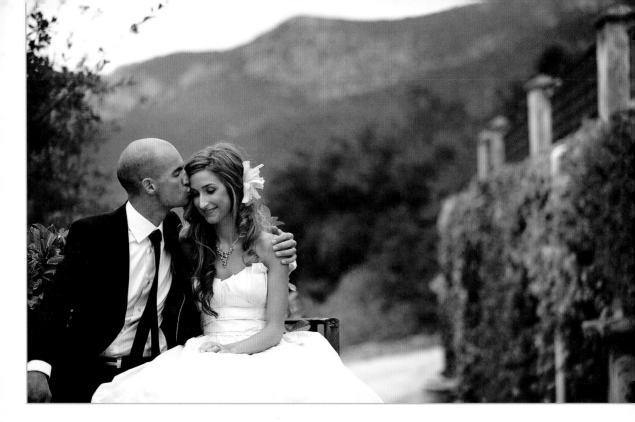

SIMPLE DIRECTION (above)

In between the vineyard and the chateau was a little driveway that hid a tiny sitting area with a bench and a fabulous view of the mountain range in the background. In this situation, I wanted a more natural portrait of Ginger and Willy, so I asked them to just sit together and interact with each other. Sometimes that simple direction can create a golden moment.

Exposure: f/2.8, $^1/_{640}$ second, ISO 400. *Lens:* 70–200mm at 105mm.

A VARIATION (following page)

After getting the shot of Ginger and Willy on the bench together, I wanted to get something a little different in the same location. I had Willy stand up on the bench beside Ginger to give the image a more dramatic feel and look as opposed to the other image. In a matter of seconds, I had created two completely different images in the same location.

Exposure: f/2.8, $^1/_{640}$ second, ISO 400. *Lens:* 70–200mm at 102mm.

"In a matter of seconds, I had created two completely different images in the same location."

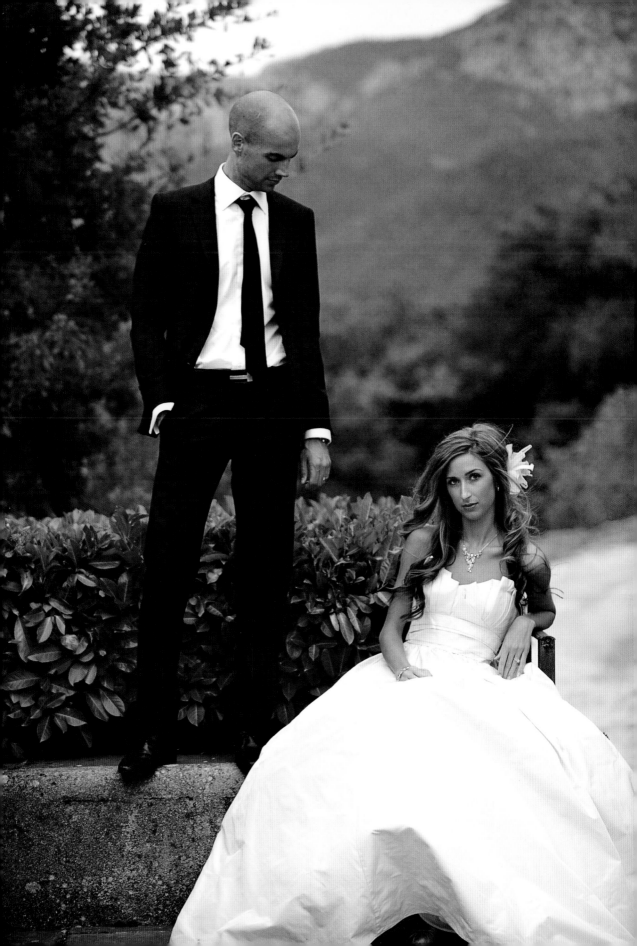

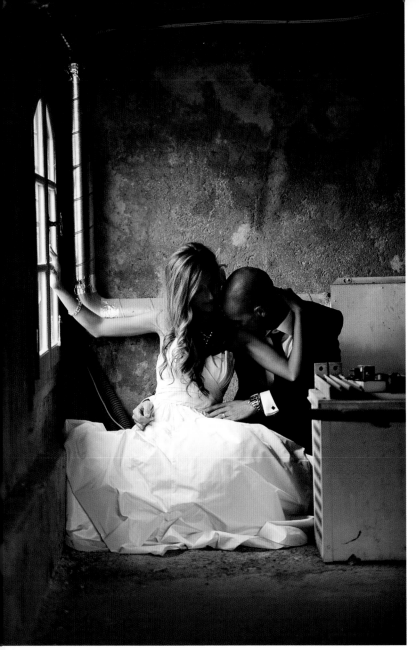

or just down the street, I look for all views, not just the ones that everyone else uses. In fact, I can't stand when someone comes up to me and tells me that this is a shot that is popular with other photographers because it makes me not want to use that location.

Exposure: f/2.8, ¹/₁₂₅ second, ISO 400. *Lens:* 70–200mm at 130mm.

HIDDEN TREASURES
(following page)

This venue offered many hidden treasures. One of them was this little staircase that led up the hill to nowhere. I had this vision of the bride climbing up the steps with the white parasol that she brought with her. Another benefit of these day-after sessions is that you don't have guests asking when you are coming back to the reception—and mom is never standing over you while you try your best to create something beautiful. It frees you and the couple to explore, take your time, and really enjoy the moments.

Exposure: f/2.8, ¹/₁₂₅ second, ISO 400. *Lens:* 70–200mm at 110mm.

IN THE GARAGE *(above)*

It may seem weird to create an image of the couple in a garage when we had access to the entire beautiful chateau where they were married the day before, but I fell in love with the light that was coming in through the window in the garage. When I arrive at a venue, whether it's in a foreign country

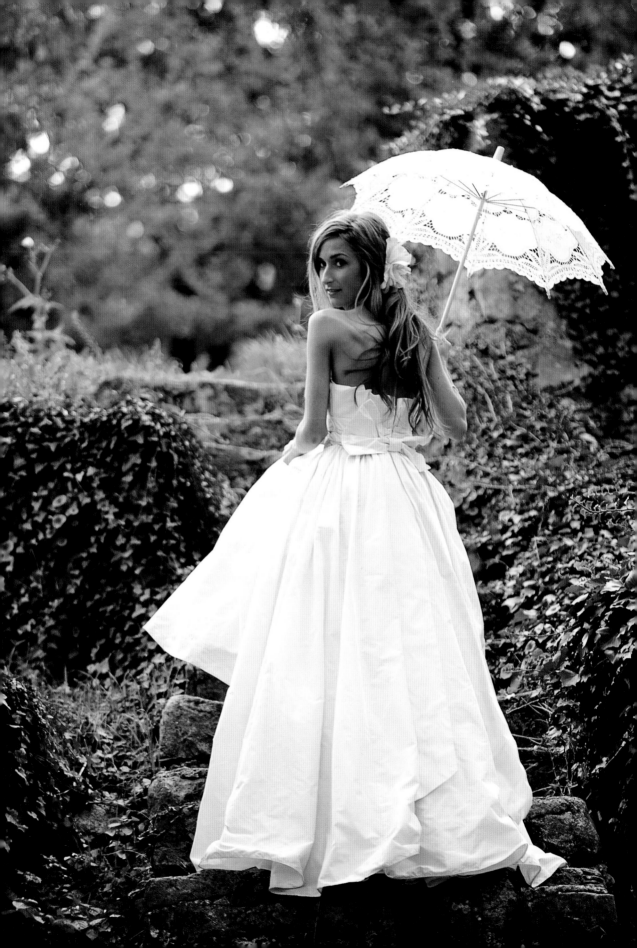

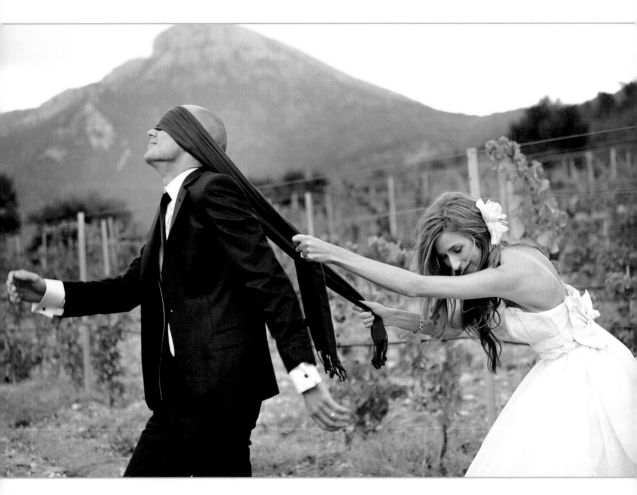

AN UNEXPECTED SHOT *(above)*

This venue in southern France was the home to endless vineyards. When we were photographing the day-after session, we took full advantage of those fields. My goal for this image was to try and get the couple to be more playful and have fun with each other. I asked them to go into the vineyard and play with the scarf that she had brought. I thought she might wrap it around his neck and draw him into her so they could kiss. Instead, I got this. It was pure magic!

Exposure: f/2.8, $\frac{1}{160}$ second, ISO 400. *Lens:* 70–200mm at 70mm.

"I thought she might wrap it around his neck and draw him into her so they could kiss. Instead, I got this. It was pure magic!"

HIGH-IMPACT CROPS *(below)*

With a little imagination and some cropping, a somewhat bizarre image can become something magical and breathtaking. The trick is making sure your clients have faith in you and trust you completely. That way, when you ask your couple to get in the really dirty excavated swimming pool, they quickly say, "Heck, yes!" Having that kind of blind faith in you as a photographer is what lets your clients get incredible images that don't look like anything else that their friends have in their wedding albums.

Exposure: f/2.8, $\frac{1}{400}$ second, ISO 400. *Camera:* Nikon D3. *Lens:* 70–200mm at 125mm.

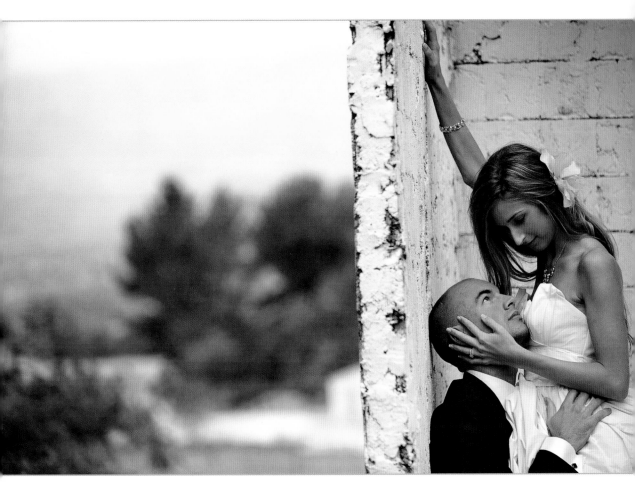

"With a little imagination and some cropping, a somewhat bizarre image can become something magical and breathtaking."

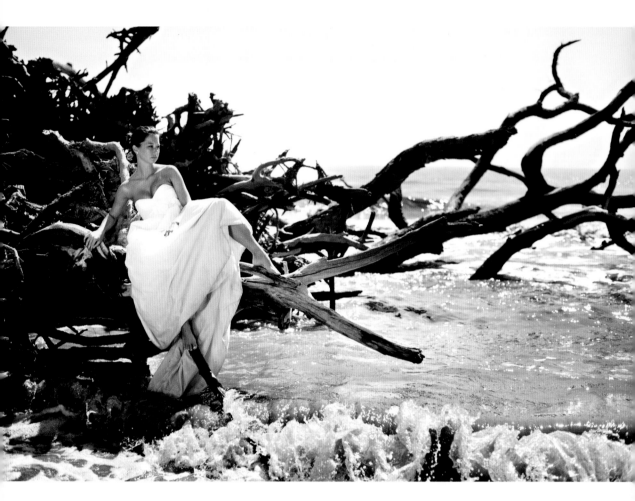

11 TRASH-THE-DRESS SESSIONS

SHEER BRAVERY (above)

I love the concept of trash-the-dress sessions. They are so much fun and can give you and your clients such breathtaking images. Months after my clients' wedding, we traveled to Jekyll Island, GA, to Driftwood Beach. Only after the session did we find out that our client was terrified of the ocean. She thought it was a cool idea anyway.

Exposure: f/2.8, $^1/_{6400}$ second, ISO 160. *Camera:* Nikon D4. *Lens:* 50mm.

"Only after the session did we find out that our client was terrified of the ocean. She thought it was a cool idea anyway."

WORTH THE RISK (below)

We were in the Dominican Republic at a great resort; this was day two of Rachel's wedding. It was the day that we agreed we would photograph a trash-the-dress session for the couple, and then somehow, Dawn and I would make it to the plane that would take us back to Atlanta for another wedding that next day. I woke up on the morning of this shoot with heat stroke, so I was terribly sick. In fact, when I was looking through these images, I didn't even remember most of them. Anyway, at the end of the session, there was a great big floating trampoline out in the ocean. I couldn't resist: I asked if the couple would mind swimming out to it and playing on it. Quick rule: if you don't ask, they won't do it! We ended up with this wonderful image of Rachel flipping in her dress. It's just too cool, if you ask me.

Exposure: f/2.8, $\frac{1}{4000}$ second, ISO 400.
Lens: 70–200mm at 135mm.

" . . . there was a great big floating trampoline out in the ocean. I couldn't resist: I asked if the couple would mind swimming out to it and playing on it."

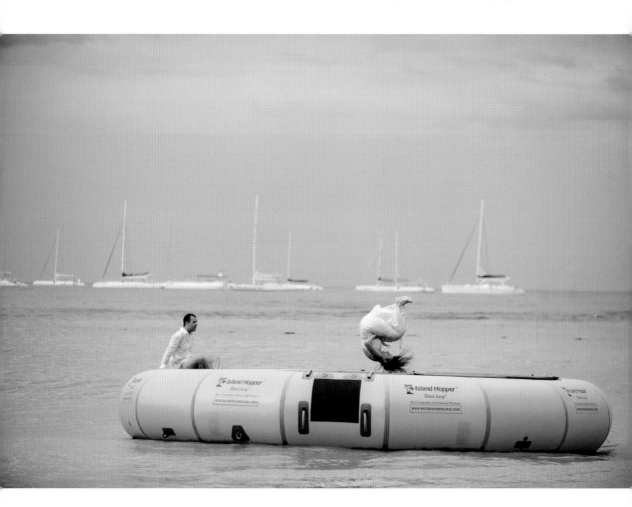

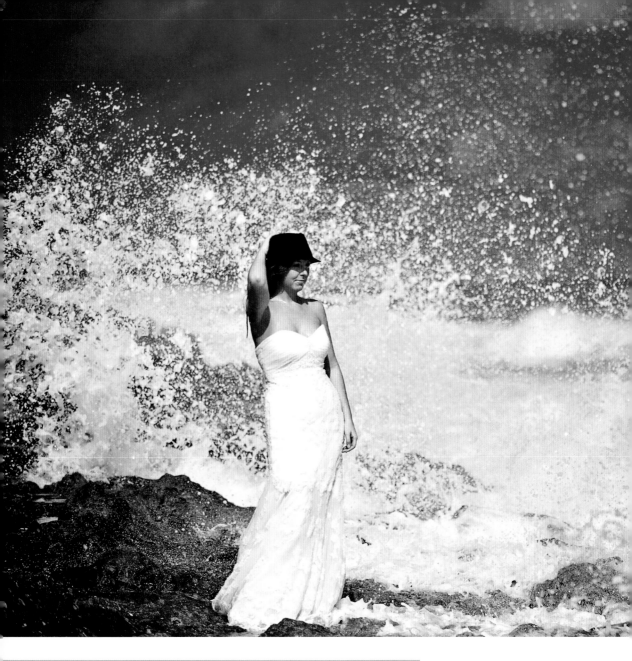

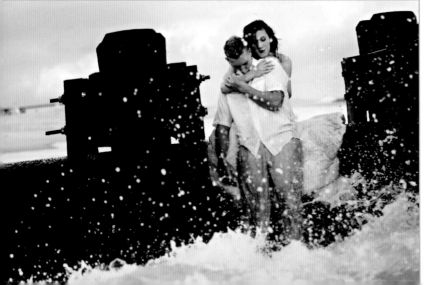

so her dress was ripe for a trash-the-dress session, which the couple chose to do at this location. This was another situation where it was absolutely imperative to protect my camera from water damage.

Exposure: f/2.8, $^1/_{5000}$ second, ISO 125. *Lens:* 70–200mm at 95mm.

HANG ON TIGHT *(previous page, bottom)*

While in New Jersey for a wedding, I had an opportunity to photograph Samantha's trash-the-dress session. I had photographed Samantha and Jesse's wedding the year before, but we didn't have the chance to do anything like this at that point. Now, I have heard stories about what you might find on the New Jersey shoreline, but that didn't stop us. So with no underwater housing or protection at all (I wouldn't suggest it!), I trudged into the surf to get these amazing images of Samantha and Jesse. There was a pipe leading out to the ocean, for reasons better left unknown, and I asked Sam to get up on it, which she did. After that, she held on tight to her man as wave after wave nearly knocked her down.

Exposure: f/2.8, $^1/_{800}$ second, ISO 125. *Lens:* 70–200mm at 95mm.

" . . . with no underwater housing or protection at all (I wouldn't suggest it!), I trudged into the surf to get these amazing images of Samantha and Jesse."

BLOWING ROCK BEACH *(previous page, top)*

This is one of the coolest places on Earth. It's called Blowing Rock Beach, and it is located near Jupiter, FL. The preserve was named for its rocky limestone shoreline. During high tides, the water breaks against the rocks and forces plumes of saltwater up to 50 feet skyward. We had already photographed Amanda and Justin's wedding,

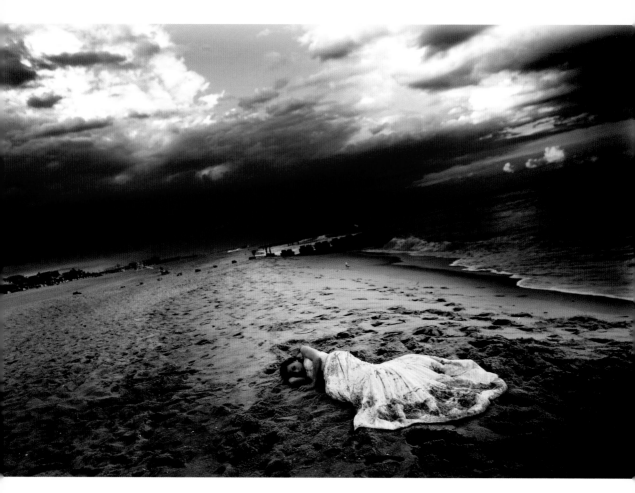

A NATURAL BUT DRAMATIC LOOK (above)

After Sam was out of the waves, I had her roll around on the beach so she would get nice and sandy. I loved the way she looked just lying there, so I shot this image. Just as an aside, I shot this with a lens that has the capability to go as wide as 17mm. Why didn't I do that here? The answer is, because I don't like super-wide images; they can look too distorted. It's my personal opinion that they can look gimmicky and overdone. I wanted this scene to look as natural as possible, with a bride lying on the beach in her filthy dress. Add in the approaching storm, and I fell in love.

Exposure: f/2.8, $^1/_{640}$ second, ISO 200. *Lens:* 17–35mm at 25mm.

"I shot this with a lens that has the capability to go as wide as 17mm. Why didn't I do that here? The answer is, because I don't like super-wide images."

GET CLOSE (below)

After Sam was done rolling around on the sand, I had her sit up on her hip. I positioned Jesse right in front of her, but a little off-center, to provide just a glimpse of Samantha without showing her whole body. I never had her brush herself off. I felt that it added to the image to have her still covered in sand.

I switched over to my 70–200mm lens for this portrait. Doing so allowed me to create a more intimate feel to the image and leave out distracting elements in the background. If it weren't for the sand, one might not even know we were at the beach.

Exposure: f/2.8, $^1/_{500}$ second, ISO 200. *Lens:* 70–200mm at 150mm.

"I never had her brush herself off. I felt that it added to the image to have her still covered in sand."

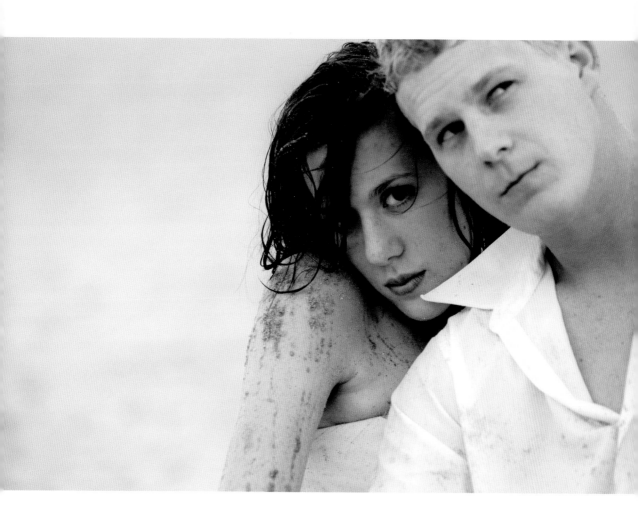

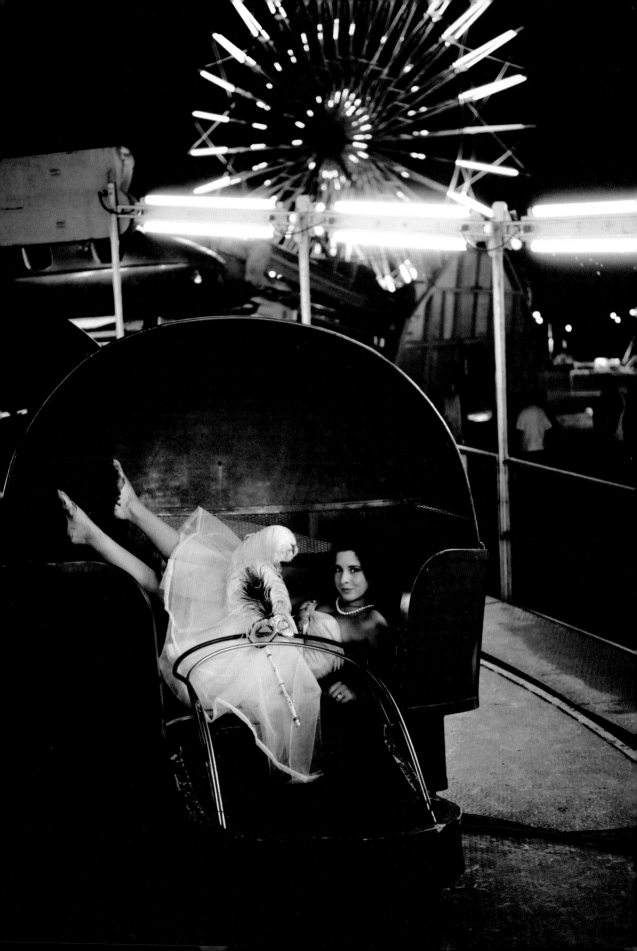

STAYING POWER (previous page)

Some sessions stay with us longer than others, and this one I will remember for the rest of my career. We were in New Jersey and we had a chance to do a trash-the-dress session with Teal. We drove to a fair that wasn't too far up the road and talked the staff into letting us photograph there. The deal was we had the run of the place as they began to pack up, as it was the last night of the fair. For this image, we posed the bride in one of the cars and used available light so we could move around faster. This resulted in me setting the ISO at 2000 to grab as much light as possible.

Exposure: f/2.8, $\frac{1}{100}$ second, ISO 2000. *Lens:* 17–55mm at 45mm.

MARDI GRAS (below)

After we finished photographing Teal in the tilt-a-whirl car, I wanted to do something different and decidedly more somber. I had her lay down on the filthy track of this ride and gave her the Mardi Gras mask that she had brought with her. I didn't use any additional lighting for this image; I relied solely on the lighting from the fairground and the ride itself.

Exposure: f/2.8, $\frac{1}{60}$ second, ISO 2000. *Lens:* 17–55mm at 22mm.

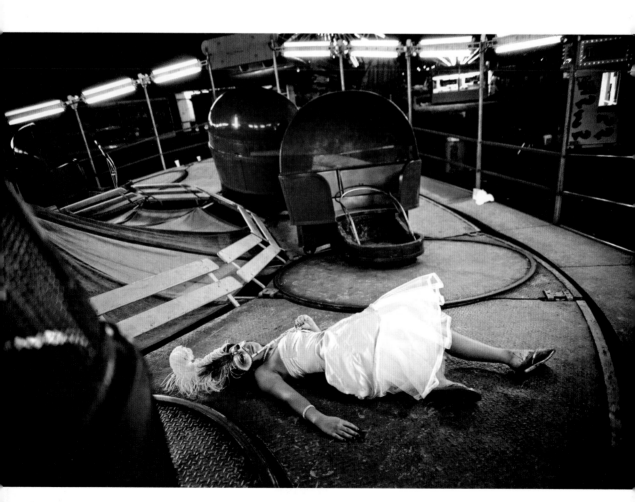

A DARING BRIDE (below)

Teal and I had talked about doing a unique trash-the-dress session during which she would be snowboarding in her wedding dress. We were up in New Jersey for her sister-in-law's wedding, so we decided to capture the images after the wedding. The problem was that it had snowed heavily in the Catskills, so we weren't able to get there—so we used the hill in her backyard. The snow was up to my knees, which stunk, because there were holes in the knees, so the snow was in my pants. With a bit of a tilt to the camera, to accentuate the slope of the hill, I shot away as the bride boarded down the hill several times. By the way, snow is an awesome reflector!

Exposure: f/2.8, $^1/_{4000}$ second, ISO unknown. *Camera:* Nikon D3. *Lens:* 70–200mm at 86mm.

"With a bit of a tilt to the camera, to accentuate the slope of the hill, I shot away as the bride boarded down the hill several times."

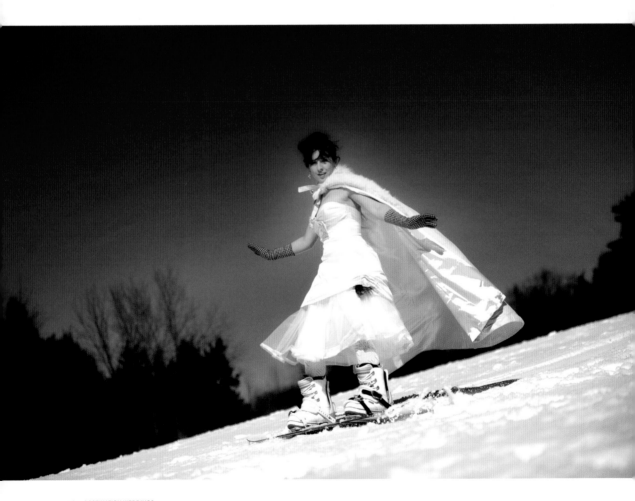

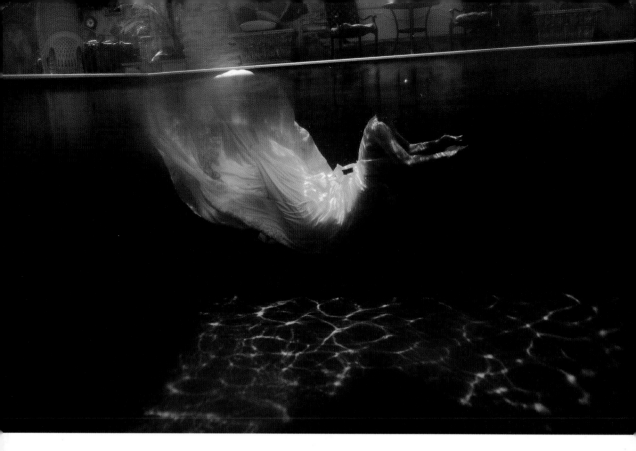

DON'T TRY THIS AT HOME (above)

When you are on the road, you don't always have access to all the equipment that you might need. This was the case for us. Let me preface the text that follows with a warning: Don't try this at home. It was the day after our trash-the-dress session, and we wanted to try to photograph some images in the swimming pool before catching our flight from Philadelphia back home. It was only a matter of time in the pool before the idea was hatched to shoot some underwater images. My main problem was that I didn't have an underwater housing, and the closest place to get one was in New York City. I grabbed some Saran Wrap and some rubber bands and Saran wrapped my camera and lens. While Dawn screamed at me from the poolside, down I went! By the way, it worked like a dream!

Exposure: f/2.8, $^1/_{1250}$ second, ISO 125. *Lens:* 17–35mm at 18mm.

"Let me preface the text that follows with a warning: Don't try this at home."

INDEX

The Shadow Effect

Internationally acclaimed photographer David Beckstead shows how shadows can become a truly intriguing device for photographers. *$37.95 list, 7x10, 128p, 180 color images, index, order no. 2113.*

Flow Posing

Doug Gordon demonstrates his fast and furious wedding photography posing techniques designed to produce great variety even when time is tight. *$37.95 list, 7x10, 128p, 180 color images, index, order no. 2119.*

Exploring Ultraviolet Photography

David Prutchi reveals how ultraviolet photography can be used for artistic and scientific purposes. *$37.95 list, 7x10, 128p, 130 color images, index, order no. 2114.*

Storytelling Portrait Photography

Paula Ferrazzi-Swift helps you create more evocative images of children and families with these simple techniques. *$37.95 list, 7x10, 128p, 180 color images, index, order no. 2120.*

How to Start a Photography Business

Tracy Dorr takes away the mystery of starting a photography business with tips, tricks, and photos from top pros. *$37.95 list, 7x10, 128p, 220 color images, index, order no. 2115.*

Painting with Light, 2nd ed.

Eric Curry's revised edition of his popular book includes even more tips for crafting amazingly detailed light-painting images. *$37.95 list, 7x10, 128p, 180 color images, index, order no. 2121.*

Retro Glamour and Pinup Photography

Brad Barton shows you the lighting, posing, and styling tricks he uses to create his vintage-style images. *$37.95 list, 7x10, 128p, 180 color images, index, order no. 2117.*

Photographing Motherhood

Caitlin Domanico and Jade Beall show you how to document the lives of women and their families. *$37.95 list, 7x10, 128p, 180 color images, index, order no. 2124.*

Light and Shadow LIGHTING DESIGN FOR STUDIO PHOTOGRAPHY

Acclaimed photo-educator Tony Corbell shows you the secrets of designing dynamic portrait lighting in the studio. *$37.95 list, 7x10, 128p, 150 color images, index, order no. 2118.*

Dog Photography

Margaret Bryant's sweet and whimsical images capture the love we have for our dogs. In this book, she reveals the secrets to creating these wonderful images. *$37.95 list, 7x10, 128p, 180 color images, index, order no. 2125.*